Studio Ceramics

Studio Ceramics

Advanced Techniques

Ceramic Arts Handbook Series

Edited by Anderson Turner

The American Ceramic Society
600 N. Cleveland Ave., Suite 210
Westerville, Ohio 43082

www.CeramicArtsDaily.org

The American Ceramic Society
600 N. Cleveland Ave., Suite 210
Westerville, OH 43082

© 2010 by The American Ceramic Society, All rights reserved.

14 13 12 11 10 5 4 3 2 1

ISBN: 978-1-57498-308-1

No part of this book may be reproduced, stored in a retrieval system or transmitted in any form or by any means, electronic, mechanical, photocopying, microfilming, recording or otherwise, without written permission from the publisher, except by a reviewer, who may quote brief passages in review.

Authorization to photocopy for internal or personal use beyond the limits of Sections 107 and 108 of the U.S. Copyright Law is granted by The American Ceramic Society, provided that the appropriate fee is paid directly to the Copyright Clearance Center, Inc., 222 Rosewood Drive, Danvers, MA 01923 U.S.A., www.copyright.com. Prior to photocopying items for educational classroom use, please contact Copyright Clearance Center, Inc. This consent does not extend to copyright items for general distribution or for advertising or promotional purposes or to republishing items in whole or in part in any work in any format. Requests for special photocopying permission and reprint requests should be directed to Director, Publications, The American Ceramic Society, 600 N. Cleveland Ave., Westerville, Ohio 43082 USA.

Every effort has been made to ensure that all the information in this book is accurate. Due to differing conditions, equipment, tools, and individual skills, the publisher cannot be responsible for any injuries, losses, and other damages that may result from the use of the information in this book. Final determination of the suitability of any information, procedure or product for use contemplated by any user, and the manner of that use, is the sole responsibility of the user. This book is intended for informational purposes only.

The views, opinions and findings contained in this book are those of the author. The publishers, editors, reviewers and author assume no responsibility or liability for errors or any consequences arising from the use of the information contained herein. Registered names and trademarks, etc., used in this publication, even without specific indication thereof, are not to be considered unprotected by the law. Mention of trade names of commercial products does not constitute endorsement or recommendation for use by the publishers, editors or authors.

Publisher: Charles Spahr, President, Ceramic Publications Company, a wholly owned subsidiary of The American Ceramic Society

Art Book Program Manager: Bill Jones

Series Editor: Anderson Turner

Graphic Design and Production: Melissa Bury, Bury Design, Westerville, Ohio

Cover Images: Catch of the Day by Lisa Merida-Paytes; (top right) Crocus Pod by Alice Ballard; (bottom right) serving bowl by Emily Reason

Frontispiece: Ice cream sundae set by Hiroe Hanazono

Printed in China

Contents

Casting Double-walled Vessels — 1
by Hiroe Hanazono

Out of Round — 6
by Ann Ruel

Handbuilding on a Stick — 12
by Mitch Lyons

Making a Sandbag — 16
by Judy Adams

Jane Graber's Miniatures — 19
by Phyllis Blair Clark

Super Size It — 25
by Joel Betancourt

Throwing Templates — 29
by William Schran

Alice Ballard's Pod Series — 34
by Katey Schultz

Fish Tales — 37
by Lisa Merida-Paytes

Eva Kwong's Biomimicry — 43
by Anderson Turner

Scott Ziegler: Pursuing Perfection — 47
by Julie Murphy

Action Figures — 51
by Dee Schaad

Multiple Firings and Mixed Media — 55
by Coeleen Kiebert

Combining Found Objects with Clay — 57
by Todd Shanafelt

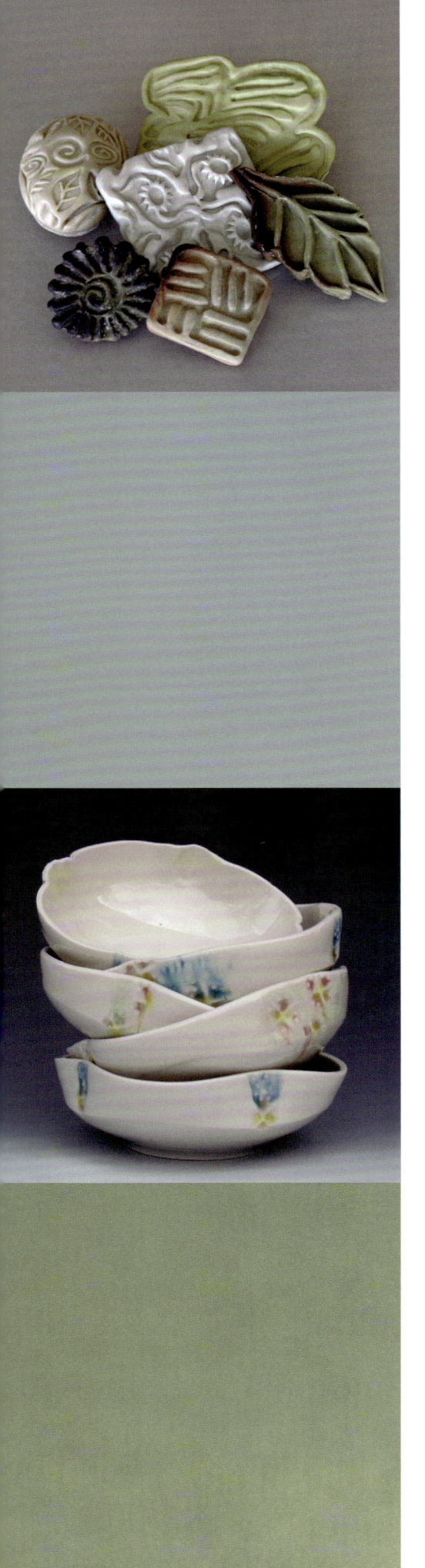

Home-grown Handles *by Stephen Driver*	**63**
Quilted Work *by Amy Sanders*	**67**
Plaster Stamps *by Meg Oliver*	**73**
Great Stamps in 30 Minutes *by Virginia Cartwright*	**76**
Expanded Faceting *by Hank Murrow*	**79**
Photo Lithography Transfer on Clay *by Kristina Bogdanov*	**81**
Easy Image Transfer *by Paul Andrew Wandless*	**87**
Fumiya Mukoyama: Zogan Yusai *by Naomi Tsukamoto*	**91**
How to Create Agateware *by Michelle Erickson and Robert Hunter*	**97**
Thrown Agateware *by Michelle Erickson and Robert Hunter*	**105**
Slipware *by Michelle Erickson and Robert Hunter*	**109**
Emily Reason's Surface Designs *by Katey Schultz*	**115**
The Clay as Canvas *by Molly Hatch*	**117**
Posey Bacopoulos: Majolica Technique *by Clay Cunningham*	**123**
Hang It Up *by Annie Chrietzberg*	**131**

Preface

If you've ever had the opportunity to attend a conference or workshop and watch a ceramic artist make a presentation, you'll find that perhaps the most exciting part is when an artist reveals one of their techniques. Let's face it; many ideas have come and gone, and then come again. However, it's through the innovation of the technique that an artist can set her or himself apart. I've sat in workshop audience and heard whispers like "Did you see that? I mean I've thrown a form like that before, but I didn't realize I could do it that way?"

It's "eureka moment" experiences that I hope you'll find as you turn each page in this book. Certainly, if you're a subscriber to *Pottery Making Illustrated* you'll find technical insights like this in every issue. Like PMI, this book offers unique looks at techniques on subjects like printing onto clay, making molds, throwing, and glazing. What I find most exciting about the techniques included is that often the artists don't know about their brilliance and/or innovation. Like all of us, they go into the studio and find themselves making work. Like all of us, they find themselves presented with a problem that they have to solve. It's their unique solutions that this book is trying to share and celebrate.

I know you'll be able to find some new idea that informs the work you're making or want to make. And I hope that through your research, you'll find success and the desire to one day share it with others like these artists have chosen to do. It's through sharing our research and our innovative techniques that will keep the studio ceramics field strong and vibrant.

Anderson Turner

Double-Walled Vessels

by Hiroe Hanazono

Double-walled vessels cast from original molds, sprayed glazes, fired to cone 6.

I've always had a great passion for food—cooking, eating, setting the table, and sharing in the full dining experience. It's why I make functional pots. The pots I create consist of simple line forms with muted glaze colors, and the work's minimal aesthetic doesn't compete with anyone's domestic surroundings, nor with the food it eventually holds.

I'm especially fascinated with design that's clean and almost severe in its simplicity, and attracted to modern interior design and architecture because both practices work to frame and contain the contents of a given space. Architects and interior designers must consider how people and furniture fit into the overall design of a space. They consider purpose, and how the space will be used. Potters must consider these same issues—good pots consider purpose, use and that which they will eventually contain.

The minimal design of my forms create an ideal setting for the display of food. Simple forms allow for beautiful relationships between the forms themselves and the elements contained within them.

1 Finished wooden patterns sealed with polyurethane and coated with mold release.

2 Molduct tubing attached to a wire frame that will be embedded into the top section of the mold.

3 Pouring slip into the pour holes using funnels.

4 Draining excess slip.

5 Squeezing slip into pour holes using ear syringe to fill the pour holes.

6 Flip the mold to allow slip to fill pour holes and finalize the casting.

My surfaces are also simple foils for the display of food. The repetition of simple geometric shapes and lines goes beyond the idea of decoration, becoming an element that blends into the form. The patterns that I create could serve as the design of the forms of my pots. They could also be rendered subtly in low relief on the surface of my pots, without interfering with the simplicity of the presentation I desire.

Making the Pattern

I use slip casting in the production of my forms. It's the technique that best satisfies my intent to create immaculately executed and unusual forms. Each new piece begins by carving out a pattern, generally made from MDF (medium density fiberboard), from which I then create a plaster mold. Once I have settled upon a design, a meticulous scale drawing is made from which I then begin laying out the MDF pattern. Because there is roughly 20% shrinkage in the casting body, I make the pattern larger than the final piece I'm aiming to produce (see box). Many other artists create

7 Use compressed air to release the casting.

8 Remove the mold when the piece is leather hard.

9 Tracing a pattern on the surface using prism projector.

10 Carving the traced lines with a needle tool

11 Filling the incised lines with a colored slip

12 Scraping excess slip flush to the surface.

their patterns out of plaster or clay, but I've found that wood and MDF better suit my needs. I can control these materials better, with the edges of my forms sharper and the transitions fairer. Also, the durability and longevity of the original pattern is a definite bonus.

The patterns are fabricated using primarily woodworking tools—band saw, table saw, sanders, router, and various hand tools including scrapers, rasps, files, and chisels. A great deal of time is also spent sanding and refining the pattern. The final step in preparing the pattern for mold making is to seal it with at least three layers of polyurethane (figure 1).

Making the Mold

First determine the number of sections the mold will have and identify the location of the plug holes. My molds are typically made in four pieces—the bottom, two sides and the top. Sometimes I embed molduct tubing that's been attached to a metal frame into one of the plaster sections to facilitate removal of the wet slip cast form from the

mold (figure 2). The tubing creates a porous channel so that compressed air can circulate through the mold and help to release the section from the casting with minimal distortion. With double-walled forms, you need to make special considerations when it comes time to make the molds. Simple open molds are not possible for I have to enclose the pattern entirely in plaster to achieve a double wall. This also necessitates creating plug holes for pouring the slip into the mold and then for draining it.

Casting the Piece

Pour casting slip into the mold and allow to set until you achieve the desired thickness (figure 3). Drain the slip from the mold and allow the piece to set up for awhile.

After draining the slip (figure 4), you'll want to fill in the openings in your form left by the drain holes, otherwise the finished piece will have holes in the bottom. Squeeze a small amount of slip into the pour holes using an ear syringe (figure 5). Plug the holes to keep slip contained within mold then flip the mold over to allow slip to fill the pour holes and finalize the casting (figure 6).

When it's time to de-mold the piece, blow pressurized air into the molduct tubing and through the plaster, forcing a separation from the slip cast form and the mold (figure 7).

Cleaning Up and Decorating

Allow the slip cast form to become firm enough to work (leather hard) then remove it from the mold (figure 8). Use metal scrapers and sponges to clean the edges and any other irregularities that appear on the surface of the form. Using a small drill bit, poke two holes in the bottom of the form to allow air movement between the inside and outside of the piece. This prevents the piece from exploding in the kiln as the air contained within the double walled form expands during the firing process.

To create a subtle decorative element for the surface of this piece, I decided to use mishima, a slip inlay technique. Using Adobe Illustrator, I create geometric patterns which I then project onto the cast form, tracing them in pencil and finally carving out the lines with a needle tool (figures 9 and 10). Colored slip is then pushed into the incised lines using a brush (figure 11). Once the slip is

dry, the surface is scraped flush with a metal rib (figure 12) removing all excess slip from the form. What remains, is a clear and clean pattern with the colored slip remaining in the incised lines.

Firing

After bisque firing to cone 06 I spray all of my glazes and fire them to a very hot cone 6. All of the double-walled pieces are down-fired as well, a process by which cooling is slowed through the gradual lowering of the temperature within the kiln. It allows for a more even cooling of the inside and outside of the form, which produces less stress on the overall form. Larger forms are glazed both inside and outside to maintain a balance of surface tension. The use of both of these techniques has reduced the amount of loss I experience in the creation of these double walled forms.

I've found that the shape and size of the forms I design greatly impacts their survival through all stages of my entire making process, from casting through firing. This is particularly true for my double-walled plates. Should the interior walls of one of these castings touch, the chances that piece will survive decreases substantially. My failure rate goes up, with losses happening in the casting process itself and in both the bisque and glaze firings. Therefore, I have to remain aware from the very beginning; in the sketching and drafting phase, how thick the walls will be and how that affects the form. Then, during the casting phase I must be diligent with my casting times to ensure the wall thickness is consistent and accurate, always trying to preserve the integrity of the negative space within the pot and preventing the walls from fusing.

Being a designer, mold-maker, and manufacturer brings me great joy. I enjoy the challenge of creating unusual, well-defined forms for use. The wooden patterns that I create for mold making and the slip casting process enable me to successfully achieve my intent. I have never had formal training in slip casting or in mold making. Working in diverse artist communities I've been exposed to a great variety of artists who have shared their tricks and techniques. It's through this sharing and this collaboration of sorts that I am able to do what I do.

Out of Round

by Ann Ruel

Oval fruit bowl, 20 in. wide, stoneware, with slips, rust red wash, white, nutmeg and chun clear glazes, fired to cone 6.

Although the mesmerizing spin of the potter's wheel originally motivated me to work with clay, I soon began to break out of those circular boundaries and started altering my pieces into more complex forms. To create asymmetrical forms, I developed a stacked plywood mold making process to create slump molds using a wood construction technique I learned from Dewane Hughes at the University of Texas at Tyler.

The tools and supplies for this technique are available at your local home center or they may already be in your garage.

Create Your Design

This mold design consists of layers of contoured plywood glued up in a stair-step fashion, which is then ground smooth. When designing and constructing the mold, work from the top layer down, keeping in mind that the mold remains open on the top and bottom.

Sketch out some shapes that you want to use and cut out a template. The shape you settle on becomes the top rim of your finished vessel. For your first mold, create shapes that have wide sweeping curves; avoid tight curves because they're hard to cut and sand.

1 Transfer your pattern to the plywood.

2 Cut out the shape.

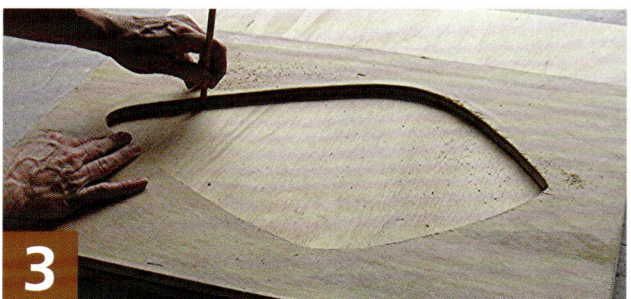
3 Trace the pattern onto the second sheet.

4 Measure in to make a smaller pattern.

Getting Started

Trace the shape onto a piece of plywood (figure 1). Place the shape so you have an extra two to four inches of wood on all sides of it. The extra wood provides more gluing surface as well as rim support.

Drill a starter hole for the jigsaw blade close to the inside of the line you drew, and cut out the inside of the contour using the saw (figure 2).

Mark which side of the plywood is the "TOP" and label this sheet as "layer #1." Use a pencil or marker to make registration marks on the outside edges of the plywood rectangle so that when all the layers are finished, you'll remember how to lay them together.

Creating more layers

Place layer #1 over the second layer of plywood and trace along the outside perimeter of the rectangle and the inside of the "shape cut" (figure 3). Take your ruler or compass and mark new measurements to the INSIDE of your "shape cut" tracing (figure 4). There are no exact measurements, the specifications depend on the form you design.

For a uniformly graduated shape, the contour outline on this second piece follows the original design,

Studio Ceramics

TIP

If you plan ahead, decide how big your plywood pieces need to be before you go to the home center. Most home centers can cut sheet materials to size in the store.

5 Stack the layers to check the contour.

6 Glue and clamp layers together.

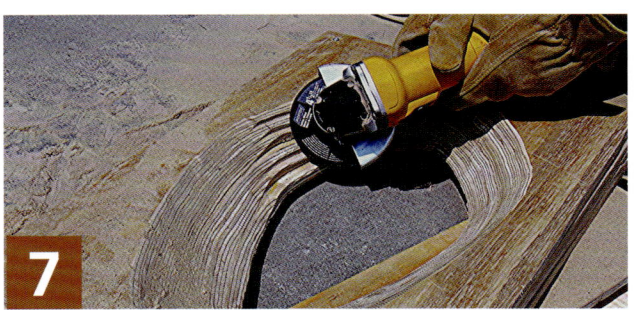
7 Contour the layers using an angle grinder.

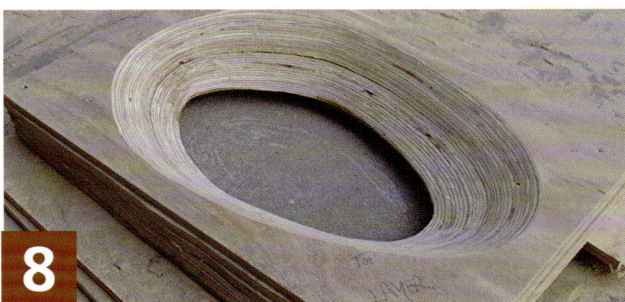
8 Finish the surface with sandpaper.

but is a smaller or scaled-down version. For a flatter form like a platter, measure in about a 1–1½ inches from the traced mark. For a deeper form like a bowl, measure in about ½–¾ inches. Note: Make sure the new pattern is smaller than the pattern you cut on the previous layer, or you'll end up with an undercut that locks the clay into the mold.

Cut the second layer, remembering to label the plywood appropriately. After you've finished, stack the two sections together again and, once they are properly aligned, extend the registration marks you drew on the edges of the first piece down onto the second one. These marks help you line everything up quickly when you're assembling the whole thing to glue it together.

Continue following this process until you have reached the bottom layer of your form.

Gluing the layers

Before you glue the sections together, do a dry run to make sure everything lines up. If you have a short stack of layers (less than five), arrange the layers, with the top being layer #1, down to the bottom in the order they were cut. Remember to keep an eye on the inside borders, making sure they are lined up the way you want them. They should appear as "stair steps" (figure 5). Don't worry if they are not perfectly aligned, as you'll eventually sand them flat. Apply a generous amount

9 Staple canvas to the top and bottom surfaces.

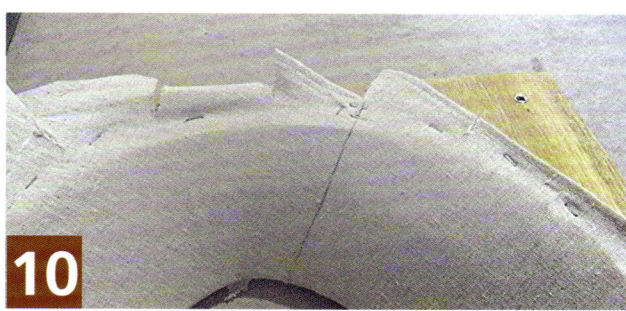
10 Cut canvas as needed to avoid folds.

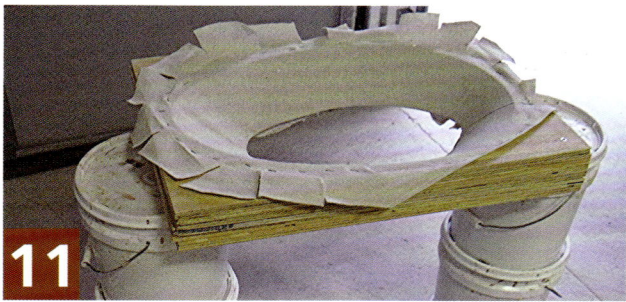
11 Elevate the mold to access the bottom.

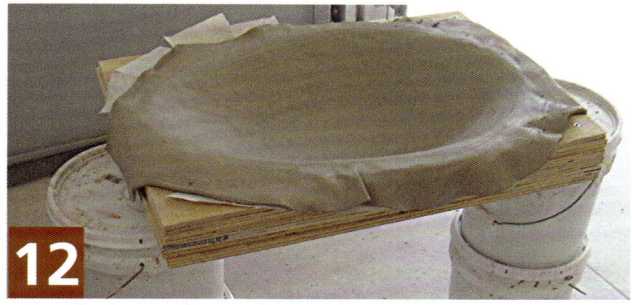
12 Gently drape clay and stretch it downward.

of wood glue in between the layers (figure 6). Use masking tape to hold the layers together so that they don't slide out of place. Then, if you have wood clamps, use them to apply pressure to the stack so that a tight bond is formed. Otherwise, drive wood screws tightly into the corners of the stack.

Refining the shape

Once the glue has dried, use the angle grinder to flatten the inside edges of your mold. To adapt the angle grinder for this purpose, you need to attach three things to the head of your grinder: the backing disc, gritted disc and the special nut. If you are unsure how to do this, use the instructions that come with the sander conversion kit. If you don't have a grinder, you can use a Surform tool and a little elbow grease to get the contour.

Prop the edges of your mold off of your work surface using plywood scraps so that you don't accidentally hit the table surface with the grinder. Slowly begin grinding down the stair steps so that your layers meld one into the next (figure 7). Continue grinding until the stair steps of the mold are as flat as you want them, then finish using sandpaper (figure 8).

The grinder is a very aggressive tool and if you are new to using it, you may gouge into the surface. Don't worry if this happens, you can always apply wood filler to smooth out those areas.

> **TIP**
>
> If your stack is taller than five layers, group your layers into smaller stacks, keeping your plywood layers in the order that they were cut. Gluing the layers together in smaller stacks keeps the layers from sliding out of place once you apply the wood glue. Follow the same rules as above to give the layers a tight bond. Once the smaller stacks are dry, glue them together in consecutive order to make the completed stack.

13 Create a rim then cut away excess clay.

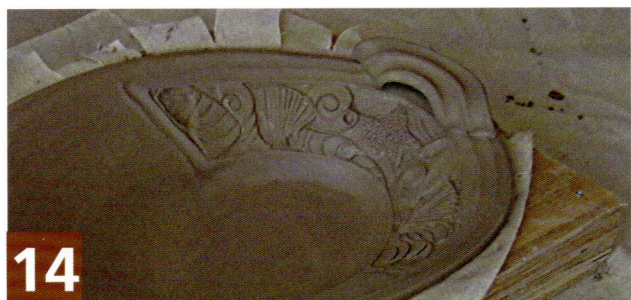
14 Add texture, details and handles.

Finishing the mold

Line the inside of the mold with painters canvas to cover up the wood texture. The canvas also allows clay to easily release. Stretch the material tight and flat while stapling (figure 9) to the top and bottom of the mold. Cut darts in the canvas to help it conform to the edges. Be careful not to make your cuts in the part of the material that actually touches the inside of the mold.

Don't let the material fold over on itself. Use your screwdriver to take a couple of staples out and try to refit the material as tightly as you can. If there is no possible way to cover the mold without having the material crease, pull the material tight along the mold wall and use a pencil to mark where the ends meet along the inside of the mold. Carefully cut the material with a utility knife along this mark and staple it down to the mold without any overlap (figure 10). Use a hammer to tap all staples securely into the wood.

Using the Mold

Because the mold is bottomless, you can experiment with different looks for your clay form. If you want to give your new piece a flat bottom, set the mold over a piece of clean canvas material on top of your worktable before adding the clay. For a more bowl-shaped bottom, design with an added foot ring or individual feet, first position your mold on supports to give yourself enough space to work below the mold (figure 11).

Next, roll out a ¼–½ inch thick slab large enough so that it overlaps the top of the mold on all sides. Gently transfer the clay over the top of the mold so that it begins to drape into the center of your opening. Slowly slide the edges of your slab toward the center until it begins to settle into the mold. You may see that the clay is beginning to fold over itself along the rim. Gently pat the clay flat with your hand so this doesn't happen. Once the clay is touching the sides of the mold, you can begin to gently

15 Add feet while the piece is still in the mold.

16 Remove form from the mold and finish edges.

work the clay downward to create the bottom of the form (figure 12).

If you're making a flat bottom vessel, gently press the clay against the canvas surface. If you're making a bowl-shaped vessel, slowly stretch the clay past the bottom layer of the mold so that it drapes into the center. Once the shape of the bottom is pleasing to you, smooth the inside of the clay with your fingers first from left to right then again from top to bottom.

Finishing touches

When the clay has firmed up to almost leather hard, it's time to form a rim. Some molds have a large opening at the mold's bottom and the clay draped over the top edge of the mold locks the form in place. If trimmed while the clay is still very wet, the form may sag or fall through.

Here are a couple of options: Make a wide rim that drapes over the top of the mold by measuring out a few inches from the mold's top edge, trim and shape it (figure 13). Or, alternatively, trim the rim flush with the mold's top edge. Once you've addressed the rim, make specific design decisions regarding the inside of your vessel, like adding texture using stamps, etc. (figure 14).

If you decide to attach feet, you can work under the piece if it is suspended high enough. Stacks of buckets supporting each end of the mold allow you room to work underneath. Remember to score the attachment points and use slip when joining the feet to the form (figure 15).

Once the piece has dried to leather hard, remove it from the mold, smooth away the canvas texture from the outside, set it on an even surface to make sure all elements of the foot make contact with it and make any other design decisions to finalize your piece (figure 16).

Handbuilding on a Stick

by Mitch Lyons

Any round form can be made using the broomstick method. Adding all your decoration through slip transfers and imbedding tinted clays allows you to integrate decorating and forming processes.

As a young undergraduate ceramic student at PCA, now The University of the Arts in Philadelphia, my professor would often tell me, "Nature is your best teacher." Not fully appreciating the meaning of his advice, I would frequently ask myself, "How could nature possibly have anything to do with making pots?" But over the years my search for the answer to that question became my interest and passion, and it was only much later that I understood the full meaning of my professor's advice.

Inspiration

One observation that has influenced my work is recognizing that nature has a completeness and harmony within itself, whether it's a leaf from a tree, a mushroom from the backwoods, an African anteater or petals from a flower. The color, form, shape, patterns, texture, line, balance, proportion, function, clarity and the logical and non-rational secrets inherent in these elements are indivisible. It became my personal challenge as a potter to integrate this natural harmony into my work.

However, forming clay on a potter's wheel, trimming, drying, bisque firing, adding color to the surface and then glaze firing simply did not have the uniqueness I was striving for. So I began to think about how I might circumvent and modify this traditional method of forming to create a more direct process that better imitates nature and captures its mystery and essential elements.

As I thought about how I might achieve this, I was reminded of the words of the abstract expressionist Hans Hoffman (1880–1966) who wrote: "An idea can only be materialized with the help of a medium of expression, the inherent qualities of which must be surely sensed and understood in order to become the carrier of an idea."

Studio Ceramics

1 Start by preparing a thick coil of well-wedged clay.

2 Insert a ¼-inch diameter dowel through the center.

3 Apply even pressure and roll the cylinder to thin the walls.

4 Paint colored slips onto newsprint and dry to leather hard.

5 Cut the newsprint covered in colored slips into the desired width.

6 Support the cylinder on a pipe and transfer the colored slip with a roller.

That was the key! Motivated by Hoffman's words, I realized that if I wanted to replicate the processes of nature, I had to incorporate its ingredients into the clay itself before the pot was formed. This opened up a world of experimentation and expression to me, and I began to innovate by adding colored clays, colored slips, textures and slip trailed lines to a thick coil of clay. I also remembered how as a child I drew on a balloon with magic markers before blowing it up, and then being fascinated as the lines became an integral part of the expanded surface. I knew I wanted to capture this idea in clay. All of this led me to use a process that I call the "broomstick" technique to create the effect I was looking for.

Materials

My interest in landscape imagery eventually led me to think of combining not just clays with different colors but also different kinds of clays. For its translucency, I began using porcelain clay to represent sky and water, and using stoneware clay to capture the opaqueness of earth. But

13

7 When you remove the newsprint, the slip remains on the clay.

8 Insert a larger dowel and roll the cylinder to expand it and embed the slip.

9 Work with colored slips applied in patterns and repeat steps 5 through 8.

10 Roll the cylinder with larger and larger dowels to thin the walls.

11 Continue to add colored slips and roll to secure the inlay.

12 Add coils of colored porcelain and roll the cylinder to embed into the surface.

Blend B-Mix and water, then add Mason stains to make colored slips. Wear a face mask when working with dry materials.

these ideas had technical difficulties—porcelain clay and stoneware clay are usually not compatible, so my problem was two-fold: first, porcelain clay shrinks more than stoneware clay (15% vs. 12%), and second, porcelain clay shrinks faster than stoneware clay, which could cause drying problems. After extensive testing and experimenting with clay bodies, I found two compatible clay bodies whose shrinkage is about the same—Orangestone, a cone 6–10 stoneware clay body made by Highwater Clays Inc. and Laguna Clay's

13 To create figures, lay out thin coils of porcelain clay onto newsprint.

14 Roll the cylinder over the coils, pressing lightly so they will attach to the surface.

15 Use a small roller to inlay the porcelain figures completely.

16 Divide the foot into three parts with marks. Pinch in to form the tripod foot.

17 Level the feet using a bubble level and a flat board.

18 Finish the lip on a wheel working very slowly (a kickwheel is best).

cone 10, B-Mix porcelain. The Orangestone comprises the main material for forming the body of a piece and the porcelain is used for adding decoration. Dried porcelain mixed with various Mason stains creates a wide range of color choices.

The forms I make are simple. Beginning with a thick coil of wedged clay, I start creating a hollow cylinder by marking the center on both ends, then inserting a ¼-inch dowel rod and rolling the clay coil with even pressure. Using a selection of dowels and cardboard tubes with increasing diameters, I expand the diameter of the cylinder, which thins the walls at the same time. Decoration (optional) is added throughout the rolling process. The resulting cylinder has no seam.

Making a Sandbag

by Judy Adams

Kumo plate and bowl. In many ways, the use of the simple, restrained pummeling of the sandbag tool is a quiet, gentle technique that reflects Kaori Tatebayashi's character and her work.

Taking part in a workshop with Japanese potter Kaori Tatebayashi introduced me to a handy tool that I hadn't come across before, but which is easy, quick and inexpensive to make from everyday materials. Kaori uses it all the time to gently shape her beautifully simple domestic forms. She told me the tool was commonly used in Japan, but had been met with curiosity when she moved to Europe to pursue her career.

Essentially the tool is a small bag of sand, used with a gentle beating motion to ease clay into or over molds. The big advantage is its ability to 'flow' into hollows and crevices without leaving the sharp marks that are so often the side effect of using rubber or metal kidneys to press clay into molds. It's easy to make a whole suite of bags of different sizes to fit the kind of mold you're using. The gentle pummeling action consolidates the clay, minimizes stretching and eliminates any air pockets, gently but firmly.

Process

All you need to make a sandbag are two rubber bands, a square of cloth, a

Studio Ceramics

1 About a cupful of sand makes a handy-size pummel.

2 Secure with a rubber band.

3 An open weave muslin fabric goes over the plastic.

4 Secure with another rubber band.

5 Using the extra material as a handle, ease clay into corners.

similarly sized square of thin plastic sheet (the kind plastic bags are made of) and about a cupful of dry sand. The cloth you use leaves an impression on the clay, so you can choose whether to use a simple open weave, or something fancier. A cotton or naturally absorbent fabric is best, as man-made materials could stick.

Spread out a sheet of plastic. Pour the sand into the center (figure 1), then gather up the sheet around the sand and secure with the rubber band (figure 2), leaving enough space for the sand to move around a little. Place the bag into the center of the piece of fabric (figure 3), and do the same (figure 4). The plastic prevents the sand from leaking onto the clay.

Using a Sandbag

Hold the spare material at the top of the bag as a handle and gently pummel the sheet of clay into the nooks and crannies of the mold. It's a reliable way to gently ease the clay into place without stressing or over-thinning areas around curves (figure 5).

17

Kumo cup and saucer with creamer. Kaori Tatebayashi's work reflects the gentle manipulation of the clay in a form.

Kaori's ceramics

Clay is in Kaori's blood. Born in a small village in Japan, noted for its fine porcelain, she grew up watching potters work. Her grandfather had a wholesale shop and traveled around with samples, taking orders for ceramic products. She says, "My favorite playground was the pottery factory where I was mesmerized, watching the craftsmen throwing."

When she was eight years old, the family moved to Kyoto, also famous for pottery. Kaori studied ceramics at Kyoto City University of Art where she gained her degrees, and then won a scholarship to the Royal College of Art in London. A spell at the Kolding Design school of Art in Denmark followed and she now exhibits widely.

Though based in London, memories of Kyoto inspire her work. She continues: "Kyoto, my second hometown, is a basin and I felt secure in its shelter of mountains. The memory of them motivated me to create my tableware range Kumo. The rims of my cups, bowls and plates resemble the gentle curve and lilt of those Kyoto mountains."

Kaori sees the roles of ceramic maker and ceramic user as an interactive experience, a view to which I can fully relate as I drink my coffee from one of her sooty-black cups every breakfast time—and it is a joy. She explains: "My objects are only truly completed and enlivened when being used. I want my tableware to be incomplete and passive so that it embraces its function of welcoming food. For me, making tableware is like breathing—a simple, natural thing. I hope the quietness and simplicity of my tableware allows it to fit into how different people live and inspire pleasurable use."

Jane Graber's Miniatures

Studio Ceramics

by Phyllis Blair Clark

From left: Actual-size redware bottle, stoneware jug with cobalt decoration, wood-fired stoneware jug and sgraffito-decorated redware plate.

Graber, who is a graphic designer, as well as a potter, credits her upbringing with her interest in art. For example, when she was 12, her father, a doctor, and her mother, an artist, moved their family of four girls and a son to Puerto Rico. Frequent drives through the countryside were often interrupted with stops to observe, admire and to photograph the mountains, flowers and other facets of nature that came to their attention. Patterns of sunlight, unusual shapes or landscape features were enthusiastically discussed as young eyes, minds and artistic sensibilities developed.

Leaving Puerto Rico to attend Eastern Mennonite High School in Virginia, as the youngest boarding student at the school, was a real culture shock for Graber. It was a traumatic experience being so far from her family and in such a totally different environment.

After graduating from high school, she was off to Hesston College in Kansas. At the end of her sophomore year, she joined her family in a move to England. While there, she lived with her aunt and uncle, Goshen College faculty members, who enabled her to earn some college credits during the year abroad. On returning to the States, she decided to continue her education at Goshen College in Indiana, planning to pursue a career in graphics and publishing. But fate stepped in and Graber became acquainted with, then intrigued by, clay. Under the tutelage of Paul Friesen at Hesston and Marvin Bartel at Goshen, she built a good foundation of ceramic knowledge and increased her skills.

Still, she did not consider claywork a possible career choice, until Sauder Farm and Craft Village, a nonprofit living-history museum in northwestern Ohio, notified the Goshen ceramics department of an

opening for a resident potter. Phil Yordy, the museum's first resident potter, was leaving the post to move on. "Thinking why not, I hopped on board the bus headed for Archbold, Ohio," Graber recalled.

After talking with Yordy, she applied for and "ultimately, got the job. It worked out to be perfect timing for me, as I was graduating that year. The museum position gave me the opportunity to become a production potter in a safe and supportive environment—enabling me to make the transition from student to professional. I cannot speak highly enough of the many kind people at Sauder and the opportunities they provided. This was the time and the place when I really learned to pot. I had to get everything set up as a production environment—the museum was starting out and I was starting out; it just all happened together."

In 1978, the village pottery was in a tiny building with minimal heat and no running water. "The winter months were very hard, and in the warmer months, I was busy demonstrating how to make pots to school groups and other visitors. All sales were handled through the village gift shop. Today, there is a wonderful new facility in which the potter works as if in his own workshop, with most purchases made in the pot shop. During my five years at Sauder Village, I demonstrated throwing pots and embellishing them with slip decoration. It was a very immediate process—with the decorating done directly on the freshly thrown piece."

Her days were filled with throwing, decorating, firing, operating the pottery and demonstrating for a host of visitors, as the village became a destination for tourists and school field trips. The gift-shop staff soon realized there was a need for a small souvenir that pupils could purchase during their visit. They wanted something made in and representative of the village, instead of resorting to an imported trinket. After some thought, Graber decided to make a simple little handled jug similar to full-sized ones made during the mid 1800s, the time period featured at the village. Wheel thrown, glazed and fired, the little jugs could be purchased for just 50¢. "They were not miniatures, nor were they to any scale—they were just small."

As a child, Graber never had a dollhouse, much less ever heard of making pots to scale for dollhouse collectors, that is until the day the owner of a miniatures shop visited Sauder Village and saw the little jugs. Intrigued, she explained that she made miniature plants and wanted someone to make pots for them. Graber replied she would be happy to do whatever she wanted.

With her client bringing her numerous magazine articles, her interest in and knowledge of the world of miniatures quickly grew. One article was on Jim Clark, a miniature-pottery maker. Photographs of his work, as well as reference to the standard scale of 1 inch equaling 1 foot, were featured in the article. Graber thought, "This looks interest-

Miniature room (1 foot = 1 inch scale) displaying Graber's cobalt-decorated stoneware, with furniture by Susie Bears and Joanna Scarboro, and painting by Susan Hutsberger.

ing, but I sort of filed it in the back of my mind, and went ahead and made the little pots for her."

Around the same time, she decided it was time for a change. After five years at the museum, the move to Middlebury, Indiana, was definitely a change. She lived in a teepee while building a solar home and a studio. During the construction process, thoughts of those scaled-miniature pots came to mind, and she decided to try to make a few to see if they would sell.

"I worked the first summer, basically in a small summer kitchen with a wood stove, a minimum of space and equipment, and in a small rented studio in Middlebury. In 1981, after a friend suggested I should do some shows, I decided to take a line of Early American–inspired pots to a wholesale show in Cleveland. I was totally amazed to sell every single piece, with enough orders to fill my summer. A new career began.

"Having started by creating miniatures in stoneware, I eventually wanted to add another dimension to my work. After viewing the Philadelphia Museum's folk art collection, I was blown away. My German heritage surfaced as I studied this collection, and I became totally committed to creating redware miniatures in addition to my stoneware line."

The redware work is done during a separate cycle, with the wheel, tools and all brushes free of stoneware clay. "I have to get myself geared up to do the redware," Graber explained. "I use tiny brushes and

Ceramic Arts Handbook

Each piece is thrown off the hump.

To maintain correct scale, extra clay is trimmed off the top.

The neck is collared in to form a jug.

Final touch-up is done with a sponge scrap.

The jug is cut off and removed from the wheel with a knife.

After attachment, the handle is smoothed with a brush.

three colors of slip to work on the freshly thrown wet pots before they are removed from the wheel head. It is essential to have the slips just the right consistency."

She works at a full-sized electric wheel, quickly throwing and decorating the diminutive pieces. Graber says her average production speed is anywhere from 1 to 3 minutes per pot, depending on complexity.

For the past ten years, Graber has fired all of her work in electric kilns, but recently she decided to experiment by firing some of her tiny pieces in a cone 11 wood-burning kiln. The first firing was wonderful, but the next was terrible. Now she is "trying to find the right clay body that will take the fire, but will also

work well for miniatures.

"When I started the miniature work, I was not too fast, as I was really struggling to learn how to make these things. I was also using the same clay I had used to make full-sized pots, which presented yet another challenge."

She has since developed a special blend of clay for miniature work, and orders 1000 pounds at a time from her supplier. "An order will usually last me for years. Ultimately, if the clay is smooth and plastic (no grog), it will work fine for miniatures. With such small pots, the stress on clay bodies is minimal.

"To make the tiny handles, the clay has to be very plastic, so well-aged clay is a must, and I inventory

Studio Ceramics

7 One bisque kiln holds about a month's worth of work.

8 Cobalt stain is applied to bisqueware with a quill pen.

9 Each piece is dipped in clear glaze and fired to Cone 8–9.

10 Redware is thrown during a separate production cycle.

11 A plate is thrown flat, then yellow and green slips are added, before the shape and rim are refined.

12

my supply on a regular basis. I need to place my order far enough ahead to ensure I will always have aged clay on hand."

For tools, she uses "tiny Japanese brushes, quills and bits of sponges. I buy quills for decorating by the gross.

"I sometimes see something in hardware stores or at miniature shows. Some of the shows are just for artisans, where a small percentage of work by other artisans can be incorporated, such as small cupboards, tables or chairs made to scale. Other shows may include tiny tools and other materials required by miniaturist artists or collectors."

She usually fires twice a month—one cone 010 bisque and one cone 8–9 glaze—in her full-sized electric kiln. (Two test kilns are used for rush jobs and for the redware.) A glaze firing requires about an hour to load, and about six to seven hours to reach cone 8–9 in the larger kiln.

Right now, there are only about a dozen other potters producing miniatures in the United States, according to Graber. "Eye and/or muscular problems have often been the cause of miniaturists having short careers in the field. The detail work takes a toll, and in mid-life they have been forced to drop out of the business."

To prevent or to alleviate the possibility of such problems, she limits herself to work periods of one-and-a-half to two hours at a time. Even so, "my eyes have deteriorated, and I

13 When the piece is dry, sgraffito decoration is carved through the slips.

23

Miniature sgraffito-decorated redware by Jane Graber, displayed in cabinet by Jim Ison.

have inspired many of today's artists, both in scale and artistry, and represent a significant move toward the standardization of size.

"Now a collector can purchase work from any number of artists and achieve a fully proportioned look. I have recently been under pressure to make things at ½-inch scale, and some collectors now want ¼-inch scale. I decided it's not worth it to me physically to pursue the very small scale. After looking at the ½-inch-scale pieces, you can see why. One would have to work under a microscope. I figure if you cannot see it with the naked eye, what's the point?"

"Until last year, I made a point of throwing some full-size pots. It was just a way of making sure that I still could throw a bigger pot. I would throw for several days because you have to get past that first day. Just adjusting to the use of my whole hand, arm and body takes a while to get back to. I am used to having my one ball of clay last for hours, not the clearing of the wheel in minutes from a single pot."

Still, she hasn't completely given up on the idea of making full-size pots, "especially after events where I've been in contact with friends who are making big pots. Then, I face the reality of the commitments I have made to shows, the necessary restructuring of the present studio, more equipment, more everything that changing to big pots would entail. And, I think of all the work we want to do on our homestead, and the big pots will just have to wait."

now use special glasses for decorating. I give myself more breaks from the tiny detail work. I am learning to take care of myself and to listen to myself. Sometimes the throwing itself will tell me when it is time to quit. I will start losing pots, and after three in a row, I know it is time for a break. I take the dogs for a walk down to the lake, watch the fish, then come back and throw more pots.

"Miniatures are made to a particular scale for collectors who need a standardization to be able to purchase from various artists. Although miniatures have been made throughout history, the standard scale of 1 inch to 1 foot has really been set in this century. The Thorne Rooms on display in the Chicago Art Institute

Super Size It

by Joel Betancourt

"Ceramic Work, New 220," 26 inches in height. Thrown and altered stoneware with an ash glaze, fired to cone 10.

My college sculpture professor once told me, "If you can't make it well, make it large." Whether that saying stuck with me throughout my academic career or I just felt that bigger was better, throwing sizable pieces has always intrigued me. My greatest challenge was actually finding a method that worked.

There were two ways I was taught to throw large vessels. The first method was to throw two sections: a bottom piece and an inverted top. Both pieces were attached, and the form was then thrown and shaped as one. The second way was to throw a bottom then attach hand-rolled or extruded coils to the first thrown piece. I found that with both ways, I could make it large, but not necessarily make it well. After some time and experimentation, I found a third way was to throw a coil on the wheel then attach it to a leather-hard piece. This method allows me to add multiple sections with ease and reduces the chances for mistakes.

Process

The process begins by throwing a bottom. This is the foundation so it should be closer to a cylinder than any other shape to prevent sagging or slumping. I also make this first piece thicker than usual to support the upper sections when they're attached. The foundation should be made using the largest amount of clay you can handle at once (figure 1).

The lip of this section needs to be perfectly centered and without any wobble (figure 2). This is one of the key secrets to using this method. If the lip is off on any section, it hinders the next addition. If there's anything wrong with the lip, it needs to be trimmed.

Once you've thrown the bottom section, round off the lip and measure it with calipers (figure 3). You can allow the section to dry natural-

1. The foundation should be made using the largest amount of clay you can handle at once.

2. The lip of this section needs to be perfectly centered and without any wobble.

3. Once you've thrown the bottom section, round off the lip and measure it with calipers,

4. You can allow the section to dry naturally or you can force dry it using a heat gun or hair dryer.

5. Open up the section to the wheelhead to create a thrown coil.

6. The center of the coil needs to be the exact size of the bottom section's lip.

ly or you can force dry it using a heat gun or hair dryer (figure 4). Throw the next section and open a well that exposes the bat. Open up the section to the wheelhead to create a thrown coil (figure 5). The center of the coil needs to be the exact size of the bottom section's lip (figure 6).

Create a concave groove (flange) using the round side of a wooden knife (figure 7), and score the section. Score the lip on the bottom section (figure 8) and add slip. Flip the coil onto the bottom section bottom section (figure 9). Check its placement by running your fingers around the outer edge of the section (figure 10). Wire off the top piece by securing the bat with your thumbs and pulling the wire through.

Once together, press the inside and outside edges of the overhanging section onto the bottom piece (figure 11). Smooth the join by pulling and throwing that area (figure 12). Essentially, the new section is pulled up and worked over like a normal cylinder. For larger work, you may

7 Create a concave groove (flange) using the round side of a wooden knife.

8 Score the bottom section lip.

9 Flip the coil over and place it on the bottom section.

10 Check its placement by running your fingers around the outer edge of the section.

11 Once together, press the inside and outside edges of the overhanging section onto the bottom piece.

12 Smooth the join by pulling and throwing that area.

need to stand and throw, but when attempting this, it's important to keep your hands still by using as much of your body as you can. I brace my elbow against my hip and help steady both hands by straightening my back and keeping my arms close to my body. This restrains my hands from any unnecessary motion while I pull the walls up.

Smooth the joined section with a rib. A larger rib or the edge of a wooden knife sometimes works better by helping you continue the line created by the first section (figure 13). Allow this section to dry then add another section repeating all the previous steps for adding a section. If you're closing off the form, the next coil should be thrown as a bowl-shape to make the process of finishing the work easier (figure 14).

If the form is to have a long or heavy neck, pay extra attention to the shoulder of the piece. Force dry the shoulder before attempting to close the form off or before pulling a more elaborate neck. When narrow-

Smooth the joined section with a rib.

If you're closing off the form, throw the next coil as a bowl-shape to make the process of finishing the work easier.

Be sure to wet your inside hand past he wrist to avoid having the clay cling to your wrist and twisting the section.

Use a sponge on a stick to remove any excess water from the inside.

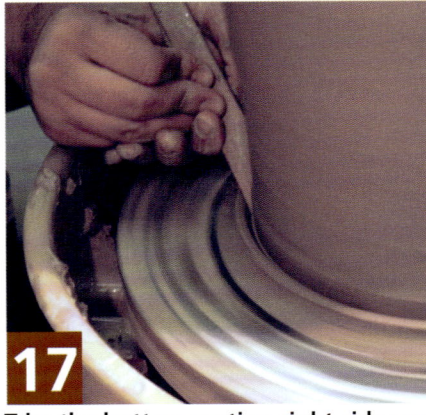
Trim the bottom section right side up.

ing the top (figure 15), be sure to wet your inside hand past the wrist to avoid having the clay cling to your wrist and twisting the section.

Use a sponge on a stick to remove any excess water from the inside. A regular sponge wrapped around a wooden dowel and held together by a rubber band is perfect for this (figure 16).

Once you're satisfied with your piece, allow it to dry a little while longer, then trim the bottom section right side up (figure 17). Wiring the form off the bat can present a problem because the first thrown section is now leather hard and gripping the bat. I've used a flat metal tool or my needle tool to help cut through the outer layer of the form. This makes wiring the piece easier.

One of the most important details of this method is to keep each section centered and the lip even. If at any point the lip becomes irregular, remove it with your needle tool.

Studio Ceramics

Throwing Templates

by William Schran

Assortment of bottle forms made with templates.

When my beginning wheel-throwing students have developed sufficient facility with clay, they're assigned the project of creating a set of four matching cups. Though I've demonstrated how to measure their forms using calipers and other devices, I continue to observe them experiencing difficulties. In an effort to overcome this stumbling block, I showed them a technique successfully used by students in a beginning hand-building class.

This technique involves using templates to repeatedly create an even, symmetrical form. In the coil-building exercise, you position the template next to the pot as coils are added, making certain the pot conforms to the profile of the template. The template is then used as a rib to scrape the surface as it's rotated, creating a smooth, uniform surface.

Making a Template

Any number of objects can be employed to design templates that have a variety of shapes. French and ships curves, found in drafting or mechanical drawing sets, are excellent tools for creating profiles for

Some of the shapes used to create design templates.

Templates used to throw cups.

Template shapes used to throw bottle forms.

1 Hold template against basic cylindrical form.

2 Push clay out to the template.

3 Hold template at an angle against surface during forming.

wheel-thrown vessels. A variety of calipers can be taken apart to create any number curved forms. Lids of various sizes can be combined to create a mixture of curves. You can also use this process to produce more complicated and compound profiles templates with relative ease.

To incorporate this technique into wheel-throwing, I began testing various materials that might serve the function of a template. Sheet plastic, a durable material that can easily be cut and shaped, turned out to be the best material. Searching through scraps available at local glass supply and repair shops, I found pieces of ¼ in. and ³⁄₁₆ in. sheets that could be readily shaped into the desired profiles by cutting them with a power saw and handsaw. The edges were then smoothed with fine sandpaper.

Creating the Form

To use a template, as in the wheel-throwing project for the set of cups, prepare several balls of clay weighing between ¾–1 lb. each. Throw a basic wide cylinder. Check the interior diameter, height and width of this basic form with calipers.

Tip: Make a template for the basic cylinder form as well as the finished piece. The first template, showing the right width and shape of the ideal starting cylinder, can help you get the right basic shape.

Studio Ceramics

4 For larger forms begin with a basic cylinder form.

5 Move the interior hand slowly up the form, pushing the clay against the template.

6 Move your interior hand from the top to the bottom, making certain the pot conforms to the template.

7 Collar the neck. Middle fingers confine the shape, thumbs push in, right index finger presses down on the rim.

8 A flexible rib removes water and slurry while compressing and refining the wall.

9 When the top becomes narrower, use slurry rather than water to lubricate the interior of the pot.

10 Use slurry to lubricate the exterior to maintain a stronger clay wall.

Once you have your cylinder ready, lubricate the interior of the pot, but do not lubricate the outside. Avoiding excess water results in a stronger form that can better withstand manipulation and alteration when using the template. Position the bottom of the template so that it's just touching the bottom of the pot and rests on the wheel head. The template should contact the wheel but should not be pressed against it. Hold the template at approximately a 45° angle, abutting the rotating clay, such that the clay moves away from the edge of the template. The template should not be held at a 90° angle to the pot as this may lead to

31

Set of cups made with a template, shino and turquoise glazes, fired to cone 10.

inadvertently shifting the template into the movement of the clay.

The fingers of the interior hand slowly move up, pushing the clay out to the curve of the template. As the pot widens, the hand must move up along the interior of the form more slowly so that it remains symmetrical. After reaching the top, the profile of the pot and template should be compared.

If the pot does not match the template, move the fingers of the interior hand down from the top to the bottom, pushing out where necessary, to conform to the profile of the template. This is often necessary for shapes with wider diameters. Refine the rim with a sponge or chamois and the cup is complete.

Large or Complex Forms

Templates are also useful in creating larger pots, particularly bottle shapes. This provides a method to quickly create multiples of the same form, but also the opportunity to explore changes to certain areas, such as the neck and rim. The process of working with larger forms follows the same steps as you would for cups, except the neck and rim are made without the template.

Make another cylindrical shaped pot, leaving the top portions of the wall, including the rim, thicker than the rest of the pot. Position the tem-

Set of cups made with a template, iron matte glaze, fired to cone 10.

plate and push the clay out to conform to the shape, moving fingers on the interior up and down as necessary. After creating the desired curve, pull up the upper portion of the wall to thin it out and narrow it in using a collaring movement. Note: It is very important to continue moving your hands up while collaring in to maintain a curve or arch in the shape of the wall. A wall that becomes too horizontal or flat may collapse. In order to collar in the pot, Using the middle fingers and thumbs to constrict the neck, As you create the neck, pressing down on the rim with the first finger of the right hand helps to maintain a level top.

Use a flexible rib after each collaring process to refine the shape and maintain the desired curve. Using the rib also removes excess water and compresses the clay. After narrowing the diameter of the pot, the wall has been thickened and can now be pulled up thinner. As the top becomes too narrow to insert a sponge to remove lubricating water from the interior, switch to using slurry to lubricate the clay instead. This allows your fingers and tools to continue shaping the clay without building up excess torque that might twist or tear the clay wall. Using slurry on the exterior, instead of water, provides a stronger clay wall.

Alice Ballard's Pod Series

by Katey Schultz

Crocus Pod, 11 in. (28 cm) in height, press-molded white earthenware with terra sigillata, fired to cone 06 in oxidation.

Alice Ballard's path in life has been as rich and textured as the surfaces of her ceramic pods. The artist spent her formative years abroad as an Air Force "brat," which shaped her values as a woman who both nests and explores, focuses and experiments. "That lifestyle made the world seem more interconnected. It made me feel very open-minded," says Ballard. "I lived in Paris from the ages of ten to twelve, but I also have memories of planting corn and beans as a young girl at my grandmother's house in South Carolina."

With just enough time at her grandmother's to stick around and see the bean sprouts peeking through the soil, Ballard's infatuation with pods might have begun at an early age. But her travels as an adult to Macedonia, China, India and Alaska suggest multifaceted influences. This has culminated in an aesthetic that heavily references the mother/child/germination metaphor and explores the more evocative realm of wonder and awe.

It seems impossible to experience Ballard's pod series without noticing the nod to such advocates of the natural world as Henry David Thoreau. "I have great faith in a seed," Thoreau wrote. "Convince me that you have a seed there, and I am prepared to expect wonders."

It is precisely this sense of wonder that is crucial to Ballard's creative process as she synthesizes what she sees in nature. The end result is not necessarily a form that exists in the natural world, but the archetypal references are evident throughout. A heart-shaped pod refers to the human body or a tulip bulb. The soft folds and openings down the center of a pod evoke flesh or unfurling petals. Some hues are muted like the forest duff, while others appear

electrified and bright like the skin of poisonous salamanders. "The older I get, the less separation I see between people, animals and plants," says Ballard.

This blending of features allows Ballard to enhance what she likes about the things she studies, and leave out what doesn't appeal to her. The most immediate effect of this enhancement is the accessibility of her work. Each pod measures roughly 11 inches long, 9 inches wide and 7 inches deep—about the size of the human face. Wall-mounted at eye level, viewers can peer into and around each pod, enabling them to see an enlarged form that echoes nature's minute miracles. The human scale lends itself to a direct relationship between the viewer and the pod, and it is in this moment that the message of Ballard's work comes to fruition. The many faces that interact with her work are as diverse and wondrous as the pods themselves, and if we allow such forms to be exalted as beautiful and awe-inspiring, isn't the entirety of creation just as extraordinary? Ultimately, it is this slow and steady work of exploring and cherishing that leads to Ballard's current body of work, which includes totems, bulbs and pod series in triangular arrangements.

Ballard's background in painting comes heavily into play during surface decoration. "I started regarding the pods as a three-dimensional

Tulip Leaf Pod in progress. Ballard uses the same press mold to make two halves of a pod, and embellishes the surface after joining the two halves.

canvas and that was the first time I started having more fun with color and texture. I use terra sigillata because it reminds me much more of paint. Whereas glaze really sits on top like the icing on the cake, I really want to emphasize the cake." Ballard prefers working with white earthenware, because the sound and feel is more like a *thug thug* than a *ping ping*. And it shrinks less than higher-fired clays, which makes it easier to plan and execute her stacked pieces.

Next is the task of arranging, which is where the individual pieces work together to leave a lasting impression. Shown in an inverted triangle form, the pods take on a more feminine meaning. "I don't consider myself to be a theatrical person," says Ballard, "but when I put these together I feel a little like I'm putting them on stage and orchestrating a drama."

Pod Triangle II, 15-pod wall installation, each approx. 11 in. (28 cm) in height, 5 ft. (1.5 m) in total height, white earthenware, fired to cone 06 in oxidation, by Alice Ballard.

Studio Ceramics

Fish Tales

by Lisa Merida-Paytes

This 14 in. (36 cm) raku-fired, skeletal fish was carved and mounted on driftwood by Lisa Merida-Paytes. She started the piece, titled "Upstream", using a plaster taxidermist mold her father originally used for mounting fish.

My father's taxidermist and slaughterhouse business was an overwhelming environment for me as a child. Scenes of hanging carcasses of deer, piles of sawed-off animal feet and freezers full of animal hides left me with powerful images, ones that presented a lack of empathy for life.

The goal of my artwork is to create a sensory experience or narrative that refers to memories of this provocative atmosphere, and also to evoke the animal spirit that was once destroyed and to make amends for the discord and waste. While my father's vocation was to permanent displays frozen in time, my work conjures the past, present and future to invoke a contemplation of our existence. I attempt to expose the unseen core, the essential structure of skeletal or embryonic animal references. I find that these references offer me an opportunity to understand our own growth and decay.

Preparing the Fish

There are many ways to prepare fish—fried, grilled, smoked, sautéed—however, you can make a clay fish using a plaster mold and "barbecue" it in a raku firing. Ironically, my mold (figure 1) is the same taxidermist mold that my father used for thirty-five years to mount fish. I remember the day I helped

1 My dad's plaster mold of a twelve pound bass.

2 Pressing and scoring clay into the plaster mold.

3 Pushing and hammering clay into the plaster mold to remove any air pockets.

4 After the clay has stiffened, carefully pull the form out of the plaster mold.

5 Trim unwanted clay from the sides and bottom of the form with a sharp tool such as a fettling knife.

6 Continue to trim clay while bending the fish to form your desired shape.

him make that plaster mold after he caught a twelve pound bass and decided to make it one of his 'frozen memories'.

To follow the process for creating a skeletal fish similar to the ones I use in my work, begin with twenty pounds of white raku clay (or whatever amount is appropriate for the scale of your press mold). Compress the clay into the completely dry plaster mold (figures 2 and 3). Smooth out the surface of the clay and allow it to stiffen for at least two hours.

As soon as the clay sets up, gently begin to separate it from the plaster mold (figure 4). Next, cut away the excess clay using a fettling knife (figures 5 and 6). Begin to bend and alter the fish into a more active gesture (figure 7) and prop it up using wads of clay so that it maintains this shape.

Now you're ready to begin carving away the clay to create the skeletal framework of the fish. Use small and large loop tools to carve the space between the spine and the ribs, and define where the skull begins (figure 8). In addition to carving, add more clay

Studio Ceramics

7 Compress and shape the clay with your hands to add a natural look and more dynamic curve.

8 Use various sized loop tools to carve away and define the fish skeleton.

9 While shaping the tail, imprint natural and repetitive surface patterns using a shell.

10 Use a long wooden skewer or any sharp tool to bore a hole through the fish head for hanging.

11 Prepare a nest of combustibles including sawdust, newspaper and straw in a trash can.

12 Place the bisqued glazed sculpture vertically inside raku kiln to avoid possible breakage to carved areas.

to enhance the form, creating a more anatomical structure. For instance, add more clay to the body to create a fish tail. And other objects can be used to create texture, for example I use a sea shell to imprint a simple line pattern on the tail (figure 9). Finish defining the head by adding and subtracting clay to define the eye and mouth area if desired.

After completing the body and tail structure, use a wooden skewer to pierce the head and bore out a hole for hanging (figure 10), then clean up any loose bits of clay that might block this opening. Next, cover the clay sculpture with plastic and let it set up for up to three days so that the carving won't be distorted when you work on the other side. Slowly unwrap the piece and gently flip it over to carve out the back side, following the same steps as above.

When finished, allow the piece to dry for about a week under plastic, then unwrap it and let it dry out completely. Allow it to dry slowly for up to two weeks because the uneven thickness created by the carving and handbuilding processes may make

13 At temperature, gently grab the fish's body close to the tail with metal tongs and place it into the metal can.

14 Carefully scrub the cooled piece with water to remove the carbon on the surface.

it prone to cracking. Taking this extra time helps ensure a safe passage through the bisque firing. Bisque fire to only cone 05, this leaves the pores of the clay body more 'open', which will later allow the raku firing post-reduction to impregnate carbon into the clay.

Raku

The raku firing process is an ancient Japanese art form, combining chemistry, fire and smoke to produce dramatic displays of color. After glazed bisque ware is fired to 1600–1800°F, the kiln is opened and the pieces are removed with tongs. Then the pieces are put in a container with combustible material, dried leaves, sawdust, newspaper, straw—anything that will burn—then the lid is shut. The burning flame needs oxygen to breathe and since it is smothered, a reduction atmosphere is created and the flame begins to search within the clay body and glazes for oxygen. This post-reduction process is why the beautiful colors and surface qualities are so unique.

Glazing

After the bisque, you can apply glazes by brushing, dipping, pouring, etc., to suit your own aesthetic. Whatever your method of glazing, remember that applying the glaze is just as important as the glaze itself, and where and how the glaze is placed on the piece can enhance, emphasize or obscure particular areas. I like to apply glazes with several acrylic brushes, a pointer to retain a high degree of accuracy and several soft towels for applying and wiping away large areas of glaze. Wiping off the surface of a freshly applied glaze with a towel allows the carbon from the post-reduction process to partially enter the clay body, creating a mottled effect. As a result of diverse glazing techniques, the ceramic piece might have three coats of glaze applied next to an area that only has one coat of glaze, or even an area that hasn't been glazed at all.

For the past several years I've used five glazes. Three are from Amaco's Old World Crackle Series (Fog Gray,

Studio Ceramics

Amber and Satin White), while the remaining two are recipes I mix in my studio (White Crackle and Copper Matt.) All five glazes mature between cones 06–05.

I've been very selective about my glazes because I want a wide variation of color, hue and texture in my palette. I knew that the more glazes I introduced, the less control I would have on the surface effects and I wanted the glazes and alternative firing process to enhance my sculptural forms. Through countless firings and a limited number of glazes, I've been able to achieve a wide range of surface color and texture using the variables of the glaze selection and application, firing temperature and atmosphere of the kiln and the post-reduction chamber.

Firing

After glazing, make a bed of combustibles in a metal can for post-firing reduction. When making the bed, think how a bird would make a nest and use sawdust, newspaper, straw, etc., to make the perfect nest for your piece (figure 11). I prefer using a combination of combustibles to prolong the smoldering period, which is usually 15-20 minutes. I use pine wood chips, sawdust, shredded newspaper and a little bit of straw or leaves. You can buy pine wood chips in pet supply stores as pet bedding in several different sizes. I like to use more pine wood chips rather than sawdust for two reasons: pine burns hotter than other woods and the wood chips are larger than sawdust, which allows for more air

TIP

As I apply glazes to my pieces, I take lots of notes and draw diagrams in a sketchbook. By recording good notes, it's possible to develop a 'quasi' controlled outcome in the unpredictable firing process.

Recipes

Copper Matt Raku Glaze
Cone 05–06

Gerstley Borate	67 %
Bone Ash	33
	100 %

Add:
Copper Carbonate	8 %
Cobalt Carbonate	2 %

White Crackle Raku Glaze
Cone 05–06

Gerstley Borate	40.5%
Nepheline Syenite	33.8
Barium Carbonate	14.9
Silica	10.8
	100.0%

flow in the chamber. Using sawdust in the bed makes the can smolder for a longer period of time, and a small amount of shredded newspaper ignites the wood chips, while straw and leaves actually imprint their organic textures on the ceramic pieces as they burn. The smoldering of combustibles helps make the glazes appear to have depth versus using more newspaper which burns fast and creates only a carbon-filled surface.

After the bed of combustibles is made, place your piece in the kiln (figure 12) and raku fire to 1600–1800°F, depending on your glazes. Using raku tongs and protective wear, gently grab the fish from the kiln and place it in the post-firing reduction chamber filled with combustible material (figure 13).

Note: Work in a well-ventilated environment. Extra airflow is beneficial with the combination of Satin White and White Crackle glazes over the ceramic surface. This rapid cooling causes the glazes to shrink even more, allowing for more carbon to reach the body and create large, bold black lines.

Once the heat from the piece has ignited the combustible material, put a tight fitting lid on the can to create the post-firing reduction. After the can has smoked for a least fifteen minutes, remove the piece and set it on a non-combustible surface to slowly cool. This is a very critical time because your piece is extremely hot and fragile and can break easily due to thermal shock. It's imperative that you use a raku clay body containing a medium grog and/or kyanite to withstand the rapid cooling that takes place. So, never throw water on your handbuilt piece right away; the uneven thickness throughout the clay body will compound the stress caused by the sudden shock of temperature change, and may cause the piece to crack or break apart. Instead let the piece cool for another ten to fifteen minutes before 'freezing' the color with cool water.

Use a scouring pad to wash away the surface carbon (figure 14). I typically resist the urge to leave the metallic color, even though it can be very attractive, and continue to wash the surface to reveal an even more beautiful inherent coloration with many tonal variations in the glaze and clay body under the surface carbon.

I've always considered the many possibilities of inherent coloration through experimentation with various applications of color and firing techniques including raku, pit fire, gas kiln reduction, etc. By varying the application of the versatile Copper Matt glaze, I've been able to produce a wide range of color that's very receptive to atmospheric changes inside the kiln as well as outside the kiln during post-firing reduction. From experiments with the application of the glaze, I've been able to get a beautiful mottled surface with a gorgeous luster sheen and opalescent color. In particular, I've discovered that applying less is better—one thin coat of glaze that is then wiped off with a dry towel works best to achieve a matt, speckled brilliant surface.

Eva Kwong's Biomimicry

by Anderson Turner

Bobtail. Eva Kwong is interested in the interconnection of everything in the world, from microcosm to macrocosm. Growing up in Hong Kong and New York, her life has been characterized by dualities both in culture and in nature. She's interested in the juxtaposition of mass/space, land/air, solid/hollow, male and female forms.

For many years Eva Kwong's iconic biological forms have been exhibited internationally and she has influenced countless ceramic artists of all skill levels. Kwong's work deals with the macro and micro parts of living organisms, but also with concepts of ornamentation, family and other issues. Not unlike the concept of energy being infused into all living things, Kwong's work is infused by the energy she invests into the material she's using.

Making Legs

Kwong begins constructing one of her sculptures by first building the "legs." These need to be leather hard so they will maintain their shape when attached to the body later. The legs are started by rolling a thick cone of rolled newspaper (figure 1). Tape it so the form holds its shape, then cover the entire cone in a plastic bag so the clay won't stick to it.

Next, working on a large sheet of heavyweight plastic, pound out a slab of clay (figure 2). Take the plastic covered paper cone, place it on the edge of the clay slab and begin rolling the clay around the cone (figure 3).

Once the clay is completely formed around the cone, trim and bevel the edge so that it's easier to put the seam together (figure 4). Score and apply slip to the seam, then work the clay together with your fingers. Roll the cone of clay several times to smooth out the seam line (figure 5).

If necessary trim the end of the cone again so it stands upright, then remove the plastic covered paper armature. Set the finished appendages on end and allow them to set up to leather hard. While they're still pliable, you can bend them to suit the sculpture you're making. Make as many appendages as you may need.

Forming a Body

Often Kwong coils her work into the form she desires. Starting with a cylinder made by wrapping a slab around a cardboard tube, she then

Ceramic Arts Handbook

1 Make a thick cone from newspaper and tape it.

2 Pound out a slab of clay on heavy plastic.

3 Roll the clay onto the plastic covered cone.

4 Trim excess clay and bevel the edge.

5 Roll the cone form to smooth the seam, then set aside.

6 Cover a cardboard tube with plastic.

uses a process she calls "blowing the form out," essentially pressing out from the inside to stretch the clay and expand the form. To make the body of the sculpture, find a tube and cover it with plastic (figure 6). An old mailing tube or one of the larger cardboard tubes from flooring stores that carpet rolls come on works well. Choose something that's big enough in diameter to comfortably reach your hand inside of it.

Pound out a large slab on the plastic sheeting. You can gently toss the slab back and forth to make it larger while it's on the plastic (figure 7). Use a rolling pin to smooth out and put the finishing touches on your slab.

Before rolling the slab around the large cardboard tube, bevel one of the edges so you can join the clay together after rolling the slab around the tube. Next, put a plastic bag over the tube, place the tube at the beveled edge of the slab, gather up the edge of the plastic sheeting and begin rolling the slab around the tube (figure 8). When you have successfully wrapped the clay around the tube, trim and bevel the other end of the clay slab, score and slip the two edges and join them together with your fingers.

The next step is to create a tempo-

7 Gently flip a thick slab back and forth to make it thinner.

8 Roll the slab over the plastic covered cardboard tube.

9 Place the cylinder on a slab, trim the excess and attach.

10 Push the form out from the inside and compress with a rib.

11 To narrow the form, cut diamonds out and close up.

12 To close up the top of the form, cut out darts and rejoin.

rary slab bottom for the piece that acts as a support while you stretch the cylinder into a more rounded shape. First, place some sand on a wooden bat so that the clay is able to move as it shrinks during the drying process, then place a round slab of clay on the bat. Stand your completed cylinder on the slab with the cardboard tube still in place (figure 9), then trim the slab to the correct size. "Sew" the two pieces together then remove the plastic covered cardboard tube armature from the inside of the cylinder.

Add a coil to the of bottom inside seam and begin to "blow" the form out by pushing from the inside of the cylinder (figure 10). Be patient as the clay can sometimes be too soft and will distort as you work with it.

To tighten up the form, cut diamond-shaped slits in the tube then press the clay inward until the edges meet and smooth them together (figure 11). To narrow the top or to begin closing up the form, cut out darts—"V" shaped pieces of clay—in the rim, then use your hands to gently close the open end of the form (figure 12).

Because Kwong's forms mimic biological forms, there are no flat surfaces. To create a rounded bottom

TIP

You can taper the thickness of the slab from bottom to top so that your final piece will be lighter on top and therefore balance more easily.

13 Remove the flat bottom then add and pinch coils to close off the form.

14 After scoring, push the leg into place.

form, once the clay is leather hard, remove the slab bottom used to support the cylinder while expanding it. To do this, and to add to the bottom end without distorting the rounded top, you'll need to make a chuck to hold the form. A great way to do this is to use an old coffee container. Roll out a thick coil of clay and push it on to the rim of the container. Cover the coil with strips of wet newsprint so the clay form will not stick to the clay ring. Next, flip the sculpture onto the coffee container and cut the bottom of the sculpture off. Attach a coil of clay to the rim and slowly close the form (figure 13).

Attaching Legs

Measure the clay cones you made earlier and cut them to equal sizes. Trim them at an angle, leaving plenty of extra clay, so that the cones do not dry too quickly and so that you have the option to trim more later if necessary to change the angle. Place a trimmed cone onto the form and mark its location. Cut a hole in the body so air will not get trapped in the leg, score and slip both pieces, then push the leg onto the body and attach with a coil (figure 14). Continue attaching appendages until you've added the number you desire.

Wooz, by Eva Kwong. While Kwong's experience at the Rhode Island School of Design Nature Lab sparked her interest in forms and concepts from nature, most of the inspiration for her work comes from observing nature and life.

Scott Ziegler
Pursuing Perfection

by Julie Murphy

As a sculptor of highly detailed pieces, Ziegler has sometimes been criticized for spending too much time on the intricate elements in his own work. Critics have suggested he find ways to speed up his process or look for alternate ways of achieving the same outcomes. But, believing in his process, and pleased with the results of his attention to detail, he continued spending countless hours creating each piece.

Though the criticism did not change the way he worked, he started to question whether he was dissatisfied with anything short of perfection, or if he held himself to an unusually high set of standards. He also wondered whether working toward continuously exceeding his own expectations was beneficial.

These questions led him to explore the idea of perfectionism. When applied to the ceramic arts, and especially to his own work, Ziegler suggests that perfectionism is more about the evolution of an artist's confidence in his processes—it takes courage to enter into new and unfamiliar territory rather than producing the same work repeatedly or simply replicating a process because it gains recognition. Mastery of material, attention to detail and flawless execution sets an outstanding piece apart from the rest.

Ziegler learned this lesson after graduating from college, while working as a toy designer for a small design firm. Side-by-side with the owner, learning the detailed work required to produce objects to scale, he acquired the skills necessary to improve his sculpting ability. He explored materials, cultivated patience and discovered the many processes needed to take a project from incep-

Studio Ceramics

Roll Model, 7 in. (18 cm) in height, colored slips and glazes, fired to cone 6.

47

Expiration Date, 13 in. (33 cm) in length, porcelain, colored slips and glazes, fired to cone 6. Photo courtesy of the artist.

tion to completion. He was encouraged to be part of the process, and taught not to accept his first idea, or even a good idea, as the gold standard. As he nurtured his creativity, and refined his skills, he sought to exceed his own expectations with the creative process and the outcome.

Ziegler saw a dramatic shift in his work. While his art had always been sculptural, his early years had been spent learning, exploring and pushing the boundaries and limitations of clay; his ideas were material-based, not idea-based. He created large-scale work, pushing the size limitations of his material. He experimented with surface decoration and the glazing process, and he developed work that combined throwing and hand-building techniques. As a toy designer, he developed and refined his meticulous attention to detail and gained confidence as an artist. He began applying the same level of precision to his own work, creating pieces unlike anything he'd ever produced before. Believing he had developed a reasonable understanding of the material, he focused on perfecting the form. He spent incredible amounts of time on each piece, concentrating on symmetry, detail and realism—elements critical to his success as a toy designer.

The precision of his forms and surface detail shifted his attention to glazes and glazing techniques. His work had always been fired in gas kilns, soda kilns and salt kilns using traditional cone 9/10 glazes, but

Studio Ceramics

because of the inconsistent results these glazes produced, they weren't practical for the detailed work he was creating now. He experimented with a variety of low-fire materials (cone 018–01), including underglazes, glazes and lusters, drawn to them because of the wide range of vivid colors available. The low-fire materials met his expectations, producing consistent results and allowing him to be more precise. He began using them exclusively.

Ziegler had taught community art classes and, though he found working at the toy company satisfying, realized he missed teaching. He had enjoyed the connections formed with students and missed watching a student grasp a process for the first time, to be inspired and put forth the effort required to be thrilled with their result, so he decided to return to school to pursue an M.Ed. in Art Education. While completing his degree, he was invited to join the fine arts faculty at a high school with a strong arts program. He received his M.Ed. during his first year of teaching there and later continued his studies in art by pursuing an M.F.A., believing one of the best ways to develop as an artist is through exposure to different and unfamiliar styles, techniques and schools of thought.

As a graduate student, he developed a body of work that pushed him outside his comfort zone as he began to confront childhood experiences he had ignored for years—Ziegler grew up in a dysfunctional family, one rooted in alcohol addiction. Building on the precision he had learned as a toy designer, his pieces became more detailed than ever before. Because he spent so much time working with and mastering his materials, he felt a sense of control over his work for

Innocence, 14 in. (36 cm) in height, porcelain colored slips and glazes, fired to cone 6.

49

the first time. He realized the detail he put into his pieces was as much for himself as it was for the viewer. It was a way for him to counteract the chaos he experienced growing up; the detail gave him a feeling of control.

In his quest for control over his art, he revisited his glazes. While pleased with the colors, stability and level of detail he was able to achieve, the porous low-fire materials he had been using were attracting fingerprints, smudges and dirt—highly undesirable effects when work is designed to engage the viewer, draw them in and encourage them to interact with it. He investigated making his own cone 6 underglazes and glazes, and after months of testing, started using commercial stains mixed with slip. He applied it to his pieces in the same way he had been using the low-fire underglazes and lusters, and was able to achieve the same results with none of the limitations. He was also able to produce a wider range of colors than ever before.

The Adversary 9 in. (23 cm) in height, porcelain, colored slips and glazes, fired to cone 6.

Stains, Slips and Patience
by Scott Ziegler

When my work is bone dry, I use a variety of grades of sandpaper to smooth out imperfections. After it is completely smooth, I begin to lay in my color. I create my own colored slips by adding different percentages of commercial stains to the same porcelain clay body used for my pieces, adding water until they become quite fluid. It's generally not wise to add wet clay to bone-dry clay, because it will crack off, but since the clay in the slip is really just an agent for binding color onto the surface, I can get away with applying many thin layers. That is the trick, but the process is very time consuming. Each area requires three to four brush coats per color. When all the color has been applied, I'm finally able to bisque fire the piece. For the glaze firing, I add glossy and matt glaze and fire to cone 6.

Studio Ceramics

Action Figures

by Dee Schaad

Detail of figures from the Seven Deadly Sins series.

Several years ago, I began making fanciful clay figures inspired by current events, literature and history. These themes have held my interest since I was a child, which proves perhaps that artistic ideas can have their roots in early experiences.

When making clay figures, I take into account many of the techniques involved in any art-making process, in addition to the typical techniques commonly associated in making ceramic objects. I select a clay type and incorporate appropriate construction and surface decoration processes. Though these choices are important, considerations of content are my primary concern. Through my figures, I try to share my observations and interpretations of the world around me with the viewer.

Themes

Content in a work of art comes from the artist's desire to share a specific idea. Content can be profound or simply a personal statement. Two years ago, I made nearly 80 pieces based on Dante's Inferno. The series included many characters described in the epic poem, but to make it more meaningful for me, I also substituted individuals from my past, from classical literature and from American history for some of Dante's original characters. The updated characters included Lady Macbeth, J. Edgar Hoover and one of my former English professors, to name a few.

These "action figures" are built using slabs textured by various found tools and stamps, coils and balls of clay for detailed features and simple tools for finishing.

Materials

The figures I make for my own work and when teaching are generally small and do not require large amounts of materials (each figure requires about two pounds of clay), so working within a tight budget is possible. I use Amaco's low fire White Art Clay No. 25–Talc Free, but any earthenware is acceptable. Surface decoration utilizes an assortment of colored underglazes, a good clear cone 05 glaze and gold and silver lusters for a luster firing. Many additional colors can be mixed, like paint, from a just few underglazes. Black is the only underglaze used in significant amounts but I dilute it about 50/50 with water.

Tools

Not many tools are needed. The process requires a sharp bladed knife, a few brushes, containers for water and slip, sponges and an assortment of other tools or found objects for making textures.

A partial list of my texture tools includes a sharpened wooden stick, an old fashioned butter paddle, parts from a ball point pen and the remains of a catalytic converter found in the street. These, along with many other items of unknown origin, give great texture. Texture stamps can also be made from clay by carving or pressing it into a textured surface like the sole of an athletic shoe. When the stamps are dry, bisque them to ensure durability.

The Process

Pay careful attention to detail. An abundance of detail is more successful in terms of developing character and narrative within a figure than the accuracy of detail.

These figures are assembled on bisqued clay slabs that are approximately 3/8 inch thick, 12 to 14 inches long and 5 inches wide. The slabs need to be prepared and bisque fired prior to beginning a sculpture, so plan ahead.

Cover the bisque slab with a paper towel or newsprint to separate the wet clay from the bisque clay. Because the slab is only bisque fired, it is still absorbent and without the paper towel layer, your figure may stick to it.

Make an assortment of heads so one can be selected to best suit the personality of the figure. Start with an appropriate sized ball of clay, make it egg shaped and add a neck. Then, cut an opening for the mouth with a knife and insert teeth. This detail needs to be completed early

Add clay to the head to form facial features. An empty ball point pen tube can create exaggerated facial expressions.

Make small slabs for the robe and sleeves. Form the slab into a shape fitting for the figure's costume and let it stiffen before attaching.

A black underglaze wash highlights fine detail work when wiped off. Any number of underglazes can be used to paint the figures.

in the process as it is difficult to do after the head stiffens. Add lips and smooth them onto the face. At this point, add clay to define the facial features, like cheeks and a nose; push depressions in the head for eyes; then add balls of clay for eye lids and the eye balls. Define the eye using various parts of a ball point pen. I'm especially interested in the facial expression and exaggerated features convey expressions more dramatically. Big eyes, a big nose and big ears may be important to the personality of the figure; don't be timid. After adding the ears, set the figure's head aside and gently wrap it in plastic for later.

Create a textured slab that becomes a robe and acts as the main body for the figure. I dress most of my figures in textured robes from head to foot. I make a small slab for the robe by throwing the clay against a piece of canvas, but a rolling pin or slab roller would work as well. Use your texture tools to press surface decoration into the clay slab. If necessary, trim the slab to a desired shape. Form the slab into a shape fitting for the figure's costume and place it on the paper covered bisque slab. Handle the textured clay as little as possible. Allow the clay to stiffen just slightly so it can be handled without rubbing out the texture. Use the bisque slab to move or carry the work in progress.

Attach the head with slip to the robe. Adjusting the angle of the head permits the figure to gaze in a particular direction, which is more

A figure from The Phony series. **A figure from the Blind Justice series.**

Add accessories for additional detail—hair, hats, jewelry, etc. A garlic press facilitates making hair. Remember to do all this without excessive handling so that the textures remain crisp.

Allow the figure to dry. Leave the figure on the bisque slab for firing as the bone dry clay will be brittle.

After the bisque firing, stain the figure with thinned black underglaze (I use a 50/50 water to underglaze ratio). Brush on a coat and wipe the surface lightly with a sponge, removing the underglaze from the high spots but leaving it in the recesses, revealing the texture. This underglaze wash creates a contrast that emphasizes texture against flat surface area. Color other areas as desired by applying underglazes like paint and allowing them to dry. Finally, if desired, glaze all or part of the figure with a low-fire clear glaze and fire to cone 05.

After the glaze firing, I further highlight jewelry or any other metallic accessories using lusters. Follow the instructions on the bottle, wear a respirator and work in a well-ventilated area. Generally lusters are fired between cone 018-019. They are expensive so consider this an optional treatment.

dynamic than if the head is looking straight ahead. Sometimes you need to support the head with a smaller piece of clay while it's drying. No problem! It's all lying on the bisque slab. Separate the pieces of clay from the head and torso with paper to prevent them from sticking together.

Make the hands, arms, sleeves and feet separately and attach them the same way the head was attached. Add as much detail as possible, since the more detail your figure has, the more personality it will possess.

Multiple Firings and Mixed Media

Studio Ceramics

by Coeleen Kiebert

Moving from throwing and handbuilding functional ware to building ceramic sculpture has been fraught with challenges. After building a piece and it's dried, I fire it to cone 05. Then I wash the bisque piece with an oxide wash, usually rutile. This deepens the look of the texture before I apply a glaze and fire the piece to cone 6. Following the glaze firing, I might add a low-fire glaze for more color, and fire the piece again to cone 05. Then I apply gold and copper luster—very sparingly, just for detail

Bardo Angel Lighting the Way, 11 in. (28 cm) in height, stoneware with glazes, lusters, mixed media and acrylic.

Bardo Shuttle XXIV, 20 in. (51 cm) in height, stoneware with glazes, lusters, mixed media and acrylic, by Coeleen Kiebert.

55

Ceramic Arts Handbook

Bardo Hookup #2, 22 in. (56 cm) in height, stoneware with glazes, lusters, mixed media and acrylic.

and touch up—and fire to cone 019. When all the firings are completed, I insert found objects into spaces that I made for them earlier, while I was building the piece. This in itself has it's own demands. I usually use quick setting epoxy and plumbers' putty, which works very well to complete the insert. Sometimes, I even need to use concrete—whatever it takes to get the piece where I think it should be.

Finally, I finish the sculpture with an acrylic patina to give it a weathered, sometimes metal or bronze look, and to tie in the look of the antique found objects.

Doing multiple firings, choosing to finish with acrylic, adding found objects, are all certainly methods that have moved me out of the realm of "pure" ceramics, but allowing myself the freedom to break the old rules and take my sculpture where I want to, gives me the satisfaction of having engaged in challenging demands—having expressed myself in my work and knowing my sculpture is truly unique.

Navigator for the Bardo #6, 11 in. (28 cm) in height, stoneware with glazes, lusters, mixed media and acrylic paint.

Studio Ceramics

Combining Found Objects with Clay

by Todd Shanafelt

"Lubrication Device," 17 inches in height, cone 4 stoneware. Thrown and handbuilt construction with stainless steel rod, wire mesh, wire, acrylic paint and stamped decoration.

My work combines slabs, thrown objects, number and letter stamps, stainless steel rods and various metal found objects, such as chains or lids. The objects that I'm most intrigued with are oil cans, grease guns and other types of automotive tools, but I also like to combine forms in clay that are reminiscent of kitchen and household appliances, such as irons, blenders and teapots, that suggest some utilitarian purpose.

My fascination with tools came early since my brothers and I were very close to my father, a master mechanic and woodworker by trade. We were constantly surrounded by hand and power tools, automobile parts, and of course, a garage filled with equipment. As an undergraduate in ceramics, I was interested in combining found objects with clay, but didn't know exactly how to do it. During my second year as a graduate student, I recommenced the investigation and developed a successful technique.

Combining found objects and stainless steel rods with clay has uncovered a new world of possibilities, and there is now little chance of any of my work leaving the studio without a found object or piece of stainless steel rod attached. With this technique, I create pieces that allow the viewers to use their imagination, wondering how, where and what they could be used for; but most importantly, my work is a true reflection of my childhood environment with roots leading back to my father's garage.

1 Start with a wheel-thrown piece.

2 Throw a thin slab onto a textured surface.

3 Roll the slab into a spout form.

4 Score, slip then push the parts together.

5 Make and add additional forms.

6 Attach found objects.

CAUTION

Wire can cut or puncture your skin, so use tight-fitting leather gloves while working with potentially sharp materials. It may take an extra minute to put gloves on, but you avoid having to wait for cuts to heal before throwing on the wheel or working with clay again.

Process

I start with a wheel-thrown piece that's firm enough to handle without bruising it (figure 1). Since my work is seldom functional, I don't leave a bottom on the form, which also allows me to manipulate the form more freely.

Next I choose a textured surface that I have taken a plaster mold of (figure 2 is a plaster mold of an old lampshade). I throw a thin slab onto the textured surface then gently pull the slab away and roll it into a spout form (figure 3).

Next, I score and slip the joining surfaces and push the parts together. The remaining spout that I am finishing is simply a solid coil that was rolled once over texture similar to the molded lampshade surface (figure 4). I continue using the textured surfaces and coils of clay together to make additional spouts, handles, drainage pipes or other forms (figure 5).

Before proceeding, I study the various objects that I've collected from thrift stores, junkyards, recycling warehouses or antique stores that may work well with the thrown form. This can is an old gas lantern or burner (figure 6), and when I turn

Studio Ceramics

7 Wrap wire around the piece.

8 Push small "staples" into the clay.

9 Press stamps into surface.

10 Attach another textured coil.

11 Attach object after glaze firing.

12 Wrap wire around and through staples.

it upside down, it fits nicely in the opening in the top of the thrown form.

I attach the stainless steel brazing rod wherever I think it fits best. I would like to think that the wire is actually protecting the spouts, handles and other protruding pieces connected to the form, so I usually have the wire wrapped around them (figure 7).

To attach the can onto the top, I make four small "staples" and push them into the clay around the neck of the form to serve as attaching points (figure 8).

Now I use several of my stamps that I've collected, and press them into the clay surface, creating technical-looking "mechanisms" or interesting connecting points (figure 9).

I decide to attach another textured coil to the form to serve as an arm for some stainless steel rod to come out of then go back into a hole (figure 10). Note: When connecting two clay pieces with a stainless steel rod, you have to account for shrinkage. If two small pieces of clay are connected to each other with the rod, they may shrink away from the wire and break. Here I've placed the other end

13 Make final adjustments.

59

of the stainless steel rod through a hole but did not pierce the clay.

I bisque fire the piece to cone 06, then brush a thin wash of black copper oxide onto the surfaces, making sure the oxide is well applied in areas where I want to enhance the textures. I spray a clear glaze then fire in oxidation to cone 2-4. After the piece is glaze fired, I attach the can securely to the top of the form (figure 11).

I punch holes in the can using a hammer and nail set. This allows a way for me to pass craft wire through and attach it to the staples on each side of the neck. I use needle-nose pliers to tightly wrap the craft wire around the staple, making sure to keep the loose ends of the wire neatly cut so that the wire wraps as evenly as possible around itself. I continue the same process of feeding the craft wire through the holes and fastening them to the staples (figure 12).

With the work completed, I can take time to critique it and make adjustments as needed (figure 13). I decided to repaint the can with chalkboard black spray paint, drew on it with colored pencils and scratched into the paint with an etching tool. I also reconfigured the stainless steel rod by sliding a long piece of a metal door spring to one side and a shorter piece on the other side.

"Cup 4L," 10 inches in height. "My work combines slabs, thrown objects, number and letter stamps, stainless steel rods, and various metal found objects, such as chains or lids."

"Lubrication Device with Hook," 14 inches in height. "My work is a true reflection of my childhood environment and roots that lead back to my father's garage."

Studio Ceramics

Wire

I found that stainless steel brazing rod works very well with a stoneware clay body, and I purchase it in 4-foot lengths at a local welding supply store. They sell it to me in bulk, so it roughly comes out to be about $8.00 per pound. The rod comes in various gauges, so experiment with different sizes. Always test the rod at the temperature you're working at. I bisque to cone 06 and glaze fire to cone 2-4, and the rod holds up well. The rod will, however, turn black and shed a thin film off of its surface, but will not melt onto the kiln shelf or onto the piece. I also use black craft wire typically found at any craft store, but this is used only AFTER the piece is fired to fasten the found object securely to the form. There is also some scrap wire mesh that I use with my work after it is fired. Regular metal wire mesh CANNOT be fired in the kiln, as it will simply fall completely apart. To attach wire mesh to a piece, try using craft wire first, but if that isn't secure enough, use a small amount of epoxy.

Tools

Here are the tools I use when handling rods, clay and found objects. Needle-nose pliers, regular pliers and wire cutters are necessary for handling the rod and craft wire. A rivet gun (shown here with various rivet sizes) works well when fastening wire mesh together. Use metal shears or tin snips when cutting large pieces of metal into smaller sizes. In addition to these tools, I use letter and number stamps, various wooden clay tools, and other found objects to press into the clay.

Textures

Textured surfaces can be made from a variety of things, such as this selection of metal surfaces. Most are scrap metal from welding shops, recycling warehouses or junkyards.

Objects

Various objects collected from thrift stores, junkyards, recycling warehouses or antique stores that may work well with thrown or handbuilt forms.

Ceramic Arts Handbook

"2L #1," 8 inches in height, thrown and handbuilt stoneware fired to cone 4. "The objects that I am most intrigued with are oil cans, grease guns and other types of automotive tools."

"Pour, Blend, Manipulate," to 9½ inches in height, thrown and handbuilt stoneware fired to cone 4. "I like to combine forms in clay that are reminiscent of kitchen and household appliances such as irons, blenders and teapots, to create pieces that suggest some type of utilitarian purpose."

Studio Ceramics

Home-grown Handles

by Stephen Driver

A few years ago, under orders from my wife, I removed a monster wisteria vine that had never bloomed in our back yard. On the way to the burn pile, I was fiddling with the vine and discovered that it was flexible and didn't crack when bent. Immediately, I wondered if wisteria would be usable for teapot handles so I started a series of experiments.

Over time I've found that the wisteria vine has some very positive characteristics. When harvested in the winter, it doesn't crack or split and is easily manipulated. After it dries, the vine is durable and easy to work into a handle, and the skin has a wonderful texture. As a handle, the vine is sturdy and rigid, but also soft and flexible so it doesn't put a lot of stress on the clay lugs when in use. It has good visual weight for use with pots and high aesthetic value. The one drawback I've found is that, although the bark is durable, it can be nicked or abraded.

The best time to harvest the vine is in the winter after they've gone dormant (figure 1). Now that I know what I want, I encourage vines to grow in certain ways. I really like the vines to grow up into the surrounding trees or as long lateral runners. You should cut the vine to a longer length than is actually needed for the handle because when you bend it, you need the extra length to get a pleasing curve (figure 2) and to tie it up with the annealed wire (figure 3).

I haven't paid attention to how long it takes for the handles to dry enough to keep their shape after the wire is removed, but it isn't very long—maybe two weeks or a month. I did discover that the vine will warp

Wood-fired porcelain teapot with home-grown wisteria handle.

some while drying, and the two sides do not always stay in line. The solution is to clamp down the ends with wood slats. After drying, you can still manipulate the handles some, in terms of changing the distance between the ends and taking the torque out, by putting them in a vegetable steamer for a few minutes and clamping them between wood slats for a day or two.

Pick out the handle that best suits your pot (figure 4). Lay the handle next to the teapot to find where to make the cuts, and mark them clearly (figure 5). Cut the vine a little longer than you think you need to give yourself some flexibility. After cutting the ends to the appropriate length (figure 6), mark where you are going to make the cuts into the handle for the lugs and again make sure they are clearly marked (figure 7).

Place the handle in a vise on an angle that makes it easy to saw, and use wood slats on the sides so you won't chew up the handle surface. I've tried several types of saws to make these cuts, and a Japanese backsaw (dozuki) is the best one yet. Carefully cut down the two sides and also in the middle, and then saw on a little bit of an angle out from the center to the sides until the pieces

pop out (figure 8). When you have finished sawing to the right depth, use a variety of rough files and sandpaper grits to get a good custom fit (figure 9). This might require several fittings on the lug until you get a snug but nonbinding fit (figure 10). Repeat the process on the other side of the handle.

The clay lugs on my teapots have a hole in the center for a dowel to go through. Carefully mark where to drill on the handle and make a hole the same size as the dowel rod you want to use. I used to take great care in measuring and marking where I drill, but now I just eyeball it. I use a Flex-Shaft to drill the holes (figure 11), but a Dremel tool or hand-held electric drill both work well. Cut off a length of wood dowel, put some wood glue on the tip and push the dowel into place with pliers (figure 12). Cut any extra dowel with the back saw.

I use rattan to cover up the ends of the handle and the lugs. First soak the rattan in water, then cut about a 10-inch piece to wrap around the ends of the handle (figure 13). The rattan wears well and looks good, and I am satisfied with it so far. When the handle is dry, I put a coating of oil over it all. I've used tung oil, linseed oil and Watco oil, and all

gave satisfactory results. I put two coats on if I have time, and I suggest to buyers that they recoat the handle once a year or as needed. This has been an experimental process, and I do not claim to have all the answers in using wisteria as a handle material. But I do like the results I have come up with in my own work.

This is just one solution, and I hope other potters experiment and discover new and different ways of using natural materials like wisteria.

Studio Ceramics

Quilted Work

by Amy Sanders

A detail showing the variety in color and surface created using Sanders' quilted construction technique.

Growing up in southern Ohio, I spent my early years watching my mother and grandmothers sew. Upon moving to Charlotte, North Carolina, I didn't have a clay studio in which to create, so I began to sew instead. Once I found a clay studio, these experiences with sewing breathed life into my clay work: patterns, textures and seams from fabrics and textiles appeared in stamped clay vessels.

Design Ideas

My first "quilted" wall pieces were created by accident. Once I started investing time in this building process, I began to intentionally look at traditions and innovations in quilting, particularly enjoying the women quilters of Gee's Bend, Alabama. I also created a wide vocabulary of clay stamps with much inspiration coming from the book Textile Designs, by Susan Meller and Joost Elfers (figure 1). Building these quilted forms fulfilled my desire to stamp and add patterns to everything. Also, I enjoyed building pieces that reflected the property of clay that is soft and pliable, appearing like fabric.

Today, I make my quilted wall pieces with the intention of showing them in a grouping. Consideration is given to how the patterns and textures of each piece will interact with one another. This building method has also developed into a variety of vessel forms including vases, bowls and teapots.

Getting Started

Begin with a relatively thin slab of fresh clay; if it's really soft, allow it to dry a little to the point that the

Teapot, 8 in. in height. Sanders created a vocabulary of clay stamps inspired by a textile design book.

Three Tugs, 10 in. (25 cm) in height (tallest). Showing pieces in groupings requires consideration of how the textures of each piece will interact with one another.

corner stands up when bent (this entire process will be done with soft clay and no drying in between). Timing is very important when it comes to handbuilding in general, and that holds true for this project. If the clay is too soft, the piece easily collapses upon itself; too hard and the clay cracks from the stress of being bent. Once the clay is at the preferred state, compress and smooth with a metal rib.

Cut out a desired shape for the wall piece, a square or a rectangle works best, and start small for the first try (about 5 inches square). These pieces look nice hung in multiples, so I often create a template from old exhibition announcement cards. This becomes the design inside the border of the piece.

Cut the square into sections similar to piecing a quilt. Impress textures into the individual sections with handmade stamps, make marks and impressions using tools or other items from around the studio (figure 2). Pressing fingers or tools into the clay while it's laying on a piece of foam can also make marks.

Piecing It Together

Turn the sections upside down. To protect the textures, lay the clay on a piece of foam. Carefully bend up the edges that will become the inside seams (figure 3).

1 Examples of stamped textures and resource book for pattern design.

2 Cut out a rectangle or square from a larger slab, then cut it into sections and impress textures on each.

3 Turn the sections upside down and bend the edges up to create the inside seams.

4 Pinch the seams between all sections together to join them together.

Pinch the seams together (there is no need to score at this point). Start with the shorter seams first, then connect the longer ones (figure 4). Cut away any clay that extends past your desired main shape. This occurs when you have a long piece connected to several smaller sections that have been pinched together.

Bend all outside edges up to prepare for the border. Turn down any inner seams first (figure 5). If your clay seems to be getting a bit dry, run a damp sponge over the edge.

Cut out four long pieces for a border (they must be long enough to extend past the inner design on both sides). Turn up edges and pinch together (figure 6). For the last piece of the border, bend the long and short edge that meet the corner and pinch them together.

Carefully roll the edge around to meet the ridge (figure 7) on all four sides. Cut out a slab that extends over half of the border. Wet and score both the border and back of slab (figure 8). Cut two holes into the backing slab that will eventually receive a wire for hanging. Before attaching the backing piece, check to make sure that no seams will block the wire between the holes, if so, push the seam over. Attach the back and compress

Studio Ceramics

5 Press down outer edges of interior seams, then bend the outside edges up. These will attach to the border.

6 Arrange the four long border pieces around the perimeter, turn up the edges then attach them to the tile.

7 Roll the edge of the border up to meet the interior seam ridge between the tile and border.

8 Cut out a slab for the back of the tile, create holes for hanging wire, then score the attachment areas.

the seams carefully with your finger (figure 9). Finish by compressing the attachment point with a wooden tool of some kind (my personal favorite is a corn dog stick).

Turn the piece over and enjoy your results (figure 10). If the border seems a bit flat, gently press the sides inward with your palm to expand the volume. If the piece is large or rectangular, wait until it sets up to soft leather hard before you turn it over. It may be a good idea to place a board or bat on top for support (sandwiching the clay between your foam and board) and turn the piece over carefully. Dry with a piece of plastic lightly draped on top to avoid warping.

Glazing and Finishing

After bisque firing, brush watered-down black glaze over the entire surface and then wipe it down with a slightly dampened sponge to expose the texture (figure 11). The black glaze will remain in any areas with textures or impressed stamps. Brush glazes and oxides on each of the different patches (figure 12). The pictured pieces contain a red iron oxide wash, rutile wash and glazes. This glazing process results in a surface that not only highlights the

9 Using slip, press the backing slab onto the tile firmly to compress the attachment.

10 Carefully flip the tile onto a board and make any final adjustments to the shape.

11 Brush a watered down black glaze over the surface of the bisqued tile, and wipe with a sponge.

stamped patterns, but also has a variety of finishes from shiny to matte, simulating different textures of fabrics.

Once it has been fired, string a short length of picture hanging wire through the pre-made holes on the back of the tile. Twist the wire to close the ends and turn the twisted area under the clay backing (figure 13). Hang it up and enjoy!

12 Apply different glazes and oxides to each of the patches to vary the surface color and sheen.

13 After the piece is fired, thread picture hanging wire through the holes on the back.

Detail, finished quilted tile.

Finished quilted tile, 5½ in. (14 cm) in height.

Studio Ceramics

Plaster Stamps

by Meg Oliver

"Jellyfish Platter," 14 in. (36 cm) in diameter, thrown and stamped porcelain with inlaid glazes, fired to Cone 9.

My mark-makers, so to speak, are plaster stamps. Most have a biological origin. Some are marks from found tools—a broken paintbrush, a grapefruit spoon, to name two of my favorites. Most of the marks are unrecognizable from their original source. On stamp-making day, I generally go for a walk, pick things from the garden or use a flower from a bouquet that is about to go. I basically collect a whole bunch of things. I then make little pinch pots and embed my treasures into the clay or decorate the inside of the pot with repeated marks. If you are trying this at home, remember that undercuts are no fun in plaster.

The plaster is then dolloped into the little pots. Any extra gets poured out onto a bunch of leaves or pine needles, or anything that could be interesting later. For a while, I was enamored by the mark left by air bubbles caught in the plaster, so I intentionally added air to the plaster mix so I could get as many as possible because they wear out quickly. I make about thirty or so stamps at a time. I peel away the little pinch pots when the plaster is still quite soft. This makes it that much easier to remove things that get embedded in the plaster. Some are amazing as little vignettes, but as stamps, are not quite what I was looking for. Some will always be what they are and do not transcend into a mark. And some, if I just cut in half or break off an appendage and rub with a green scrubby—Aha! A new favorite!

Vase, 12 in. in height, thrown and stamped porcelain with inlaid glazes.

Left: A selection of pinch pots with various embedded treasures is ready for plaster.

Top right: After plaster is dolloped into the pots, they are left to stiffen up. Oliver removes the pinch pots when the plaster is still a little soft because it is easier to remove things that get stuck.

Bottom right: The plaster mold on the right was stamped into the soft clay on the left.

Cherry Blossom Mugs, 4 in. (10 cm) in height, thrown and stamped porcelain with inlaid glazes, fired to Cone 9.

Studio Ceramics

Stack of sorbet bowls, 5 in. (13 cm) in height, thrown and stamped porcelain with inlaid glazes.

Great Stamps in 30 Minutes

by *Virginia Cartwright*

Polymer clay can be used to create a variety of clay stamps in a short period of time.

Stamps enhance your work by adding interesting textures to your pieces and depth to your glazes. For years, I carved stamps from small plaster blocks or from leather-hard clay that was then bisque fired before use. I wanted a way to make stamps more quickly so I could share them with my students and workshop participants and found that polymer clay (available at most craft stores) makes a clean, crisp impression that can be cured and ready for use in almost no time at all.

When making a stoneware stamp using regular clay, you need to let it dry then bisque fire it before you can put it to use, which could take several days to a week. Polymer stamps, by comparison, are ready for use in about 30 minutes. You can then take those stamps, press them into another piece of polymer clay, and quickly get a negative version of your designs.

Polymer clay does not crack or crumble as easily as stoneware or earthenware clays, and scraps can be easily recycled. Since it's not water based, the clay doesn't dry out. This property also makes polymer clay an ideal material for making impressions from a variety of objects, including antique furniture, kitchen tools, buttons, Indian wood blocks and tombstones.

As I began to explore the possibilities of this material further, I discovered that I could use my inlaid colored clay techniques to make the stamps beautiful as well as functional. By layering and blending colors, I can create an endless variety of intricate patterns.

Pottery Making

Process

Condition the polymer clay by rolling it ten times through a pasta maker on the thickest setting (figure 1). If you do not have a pasta machine, manually roll the clay into coils in your hands. Your body heat will soften the clay. If you want to mix your own colors, make coils of two or three colors, roll them into one coil and twist the coil like a candy cane. Cut the twisted coil in half, join the two pieces and twist them again, repeating this process until the colors are blended.

You can make stamps using several layers of polymer clay by first rolling it out into a slab that is about ¼ inch thick. Thin polymer clay slabs take a deeper, clearer impression than a thick one. Put a pinch of baby powder or cornstarch on one side of the clay. Next, press the clay (powder side down) on top of a textured object. Place the polymer clay over the texture and press it with your thumbs, rather than pressing the texture down onto the polymer clay (figure 2).

Leave the polymer clay on the textured surface and add a second layer of Super Sculpey clay (figure 3). Press the layers again with your thumbs. Remove the clay and trim the edges.

Bake the polymer in a small toaster oven, following the directions given on the package. Typically, it will bake at 275°F for fifteen minutes, though you may increase the time by five minutes if the stamps are very thick. Be careful not to overheat the polymer clay. You can cover your pieces with aluminum foil to prevent scorching and blistering (figure 4). If you smell a strong odor while cooking the stamps, it means that they are getting too hot. Turn off the oven, and ventilate the room.

Finally, add a top decorative layer and a handle. I join everything together with a thin coat of liquid polymer clay and cure the piece again. The heat fuses the layers and handle together.

Supplies

There are several brands of polymer clay available (Sculpey, Fimo or Premo), all of which are good. Sculpey has a product called "Super Sculpey" which I use because it is a strong, shatter-resistant material. Super Sculpey is only available in a tan color, so I combine it with about 25% of another color of polymer clay if I want to change the color.

You'll need a clean, non-porous surface to work on, and a Plexiglas roller made just for polymer. You can substitute this roller with an 8-inch piece of plastic pipe. You should also buy a 6-inch long cutting blade and an inexpensive pasta machine (both available at craft stores or garage sales). The pasta machine is used to soften the clay and to blend the colored clays together.

If you're just making a few stamps, you can use your hands and roll the clay into coils until it softens. I find it helpful to attach handles to the stamps. Buy a bottle of liquid polymer clay and use this as glue to attach the polymer handle to the top of the stamp.

Polymer clay stamps are best when used on slightly firm slabs of ceramic clay. If the stamp sticks to the clay during use, baby powder or cornstarch can be used as a release agent. These embellished slabs can be used to make handbuilt vessels and sculptures, or left flat for tile work.

Studio Ceramics

Expanded Faceting

by Hank Murrow

Faceting a pot—slicing clay from the form using a fettling knife, wire tool, or sometimes a Surform tool—is usually done at the leather-hard stage. Several years ago I saw Joe Bennion facet bowls while they were still wet—just after the initial form was created—then continue to throw to create a stretched facet. Through experimentation, I created my own version of this process, as well as a wire tool with interchangeable wires to achieve different surface effects. Here's the method I use.

Process

To make a faceted bowl, begin with 2½ pounds of clay and open the form like a bowl, ribbing the bottom so you don't have to trim too much clay later (figure 1). The bowl is kept to a cylindrical shape, keeping the wall thickness to about a ½ inch or a little more. I rib the inside as well to eliminate finger marks (figure 2), and then give the rim a beveled profile with my chamois or rib (figure 3).

The first cut with the wire tool trims away about a third of the wall and is cut parallel to the wall profile (figure 4). Turn the wheel 180° and make the second cut, then 90° for the third cut and another 180° for the fourth. Cut the facets between the first four cuts (figure 5) and smooth the edges with a wet finger.

Use a dull wooden rib and dry fingers to open the bowl, stretching the wire cuts and dropping the rim (figure 6). It takes about three passes to develop a full bowl shape. When the bowl has half-dried, turn it over and place on a sheet of foam rubber to protect the rim.

When ready to trim, place the bowl on a damp clay chuck and use a small piece of plastic as a bearing surface for the finger while trimming the outside (figure 7). Follow by trimming the inside and finishing the foot with the chamois.

Bowl, 4½ inches in diameter. The finished piece has a lively quality, which is a result of the dynamic process of opening the bowl after faceting.

Ceramic Arts Handbook

Hank developed this faceting tool (Hank's WireTool) with interchangeable wires, which yield different patterns in wet clay. (Note: Search "Hank's WireTool" on the internet for more information.)

80

Studio Ceramics

Photo Lithography Transfer on Clay

by Kristina Bogdanov

Endangered Species, 4 inches in height each, porcelain Polaroids with photo transfer printed images, cone 6, by Lisa Dorazewski.

Clay is one of the most receptive materials and its ability to record even the delicate pattern of a fingerprint has been the biggest motivation in my work. Although I focused on sculpture and pottery as an undergraduate, I fell in love with printmaking while in graduate school. Wanting to combine two-dimensional media with my three-dimensional work, relief printing on clay seemed a natural starting point, since clay can pick up almost any texture. Moving forward, I began layering images, working with photo transfer techniques on clay work that would survive cone 6 firings. The resulting technique is closely related to traditional lithography.

Printer

Using a Xerox image, gum arabic and inks made from linseed oil and Mason stains, you can mimic the lithographic process on clay. When the image passes through a photocopier, a heat process burns the image onto the paper with a thin layer of plastic material, fixing the image to the paper, and making it nonporous. This nonporous area repels water, but attracts oil-based inks while the bare paper does not. (Note: Images from ink-jet printers won't work for this process, since most of the inks in these printers do not repel water. If you don't have a photocopier, try your local library or a copying service like Kinkos.)

Ceramic Arts Handbook

Tools

All of the supplies you will need to do this process can be found online or at art stores, many can be found at craft and hobby stores too. The tools you'll need include:

Brayer a hand roller used to spread the ink out into a thin layer on the glass and apply it to your image.

Photocopied image with high contrast or an image altered in Photoshop using half-tone dots to create gray areas.

Spatula, scraper or putty knife for mixing the ink and applying it to the glass.

Mason stains or metallic oxides containing cobalt or chrome for use as colorants.

Gum Arabic to hold paper in place and to remove excess ink from white areas of the photocopy.

Linseed Oil for mixing ceramic ink.

Small sponge for wetting paper and cleaning off excess ink.

Medium sized metal bowl for water/ gum arabic solution.

12×14 or larger piece of tempered glass or similar glass surface for mixing and spreading the ink.

1 Coat a clean glass surface with a small amount of gum arabic.

2 Spread enough gum arabic onto the glass to cover the back of the paper.

3 Place the photocopy on the glass. Spread gum arabic onto the image.

4 Put several drops of ink onto the glass surface.

Ink

The key to successful viscosity transfers depends on mixing the correct ceramic ink; the chemical make-up of the Mason stains you use determines whether the process will work or not. For example, when helping a student, the first ink we tested used Mason Stain 6650 black and the test failed. We tried this black ink several times, altering the photocopied image, testing very moist, fairly moist, leather-hard and bone-dry slabs, altering the ratio of Mason stain and linseed oil, but it simply didn't work. Finally, at the point of complete disappointment, I decided to try a different stain, Royal Blue, and it turned out to be our "lucky accident." The first run with this stain printed perfectly.

What happened? MS 6650 is a cobalt-free black, while MS 6339 Royal Blue contains cobalt. So far, all the stains that contain cobalt and chrome, including MS 6339 Royal Blue, MS 6537 Mouse Gray and MS 6109 Deep Brown, work with this printing process and the transferred image withstands both cone 6 and cone 10 firings. Metallic oxides, including manganese oxide or iron oxide, also make fine ink. If you want a wider color palette, mix small test

5 Use a brayer to spread the ink into a thick layer onto the glass.

6 Ink the image with the brayer using gentle and even pressure.

7 Squeeze some water and gum arabic solution onto the photocopy.

8 Clean ink from the white areas of the image and blot excess water.

9 Carefully lift the inked photocopy from the glass.

10 Place inked photocopy face down on leather-hard vessel.

batches of ceramic ink using the colors you want to try, and print with it on test tiles or slabs before using it on a finished piece.

Select an Image

Getting a crisp, perfect transferred image depends a lot upon the contrasts in the xeroxed image. Although gray tones will print, you get the most vibrant transfers from high contrast images. If you have a lot of gray tones that you don't wish to compromise by adjusting the contrast, use Photoshop to modify the image so gray areas are created using half-tone dots. This creates the effect of middle tones using only black and white dots. Create a mirror image of the source, again using Photoshop to ensure that any text will read as it should, rather than backwards. Once the source is ready, photocopy it so the image will transfer properly.

Mix the Ink

Mix a small quantity of ceramic ink using two parts dry stain to three parts linseed oil. Be sure to wear gloves and a respirator whenever working with dry materials. The consistency of the mixed ink should be like that of acrylic paint. If you've

TIP

Mix only enough ink that you can use within a week or two. Even if you store inks in sealed containers, they tend to dry out quickly, especially during the summer months. Once dried, ink cannot be used or fixed by adding more oil.

Studio Ceramics

10 Press down gently on the back of the paper with a sponge.

11 Remove the paper when it is completely dry.

12 Original photocopy and leather-hard vessel with transferred image.

TIP
Be careful that you don't use too much gum arabic, as it will cause problems when you roll the ink onto the paper.

TIP
Though prints are always monochromatic, you can print over underglazes or slips to increase the color range of the overall image.

added too much oil, the ink will run off of the spatula too fast and as you roll it, the brayer will have an uneven, textured coat of ink.

Prepare Your Image for Printing

Once you have the image ready, coat a clean glass surface with a bit of gum arabic (figure 1). Gently spread gum arabic with the palm of your hand (figure 2). Lay the Xerox copy over it, with the image side facing up. Run your palm over the image, spreading the rest of the gum arabic and making sure that the paper is adhered to the glass surface correctly (figure 3). The gum arabic on the surface will keep the ink from filling the white areas of the image.

Fill a medium-sized bowl with water and a splash of gum arabic. This is the solution used to wash out the excess ink that you roll on the Xerox image in the next step.

Spread the Ink
Using a spatula or scraper, scoop out some of your pre-mixed ink and trail several drops of it onto the glass surface (figure 4). Keep several inches between your image and mixing area clear of ink. Spread the ink out into an even layer on the glass by rolling the brayer through it as you would with a roller when applying paint to a wall (figure 5). Once the ink is spread out, roll the brayer over the inked-up glass a few times to evenly coat the roller surface.

Apply Ink to the Image
Apply gentle pressure when inking the photocopied image (figure 6). You'll notice almost immediately how the ink is sticking to the black of the photocopy as well as to the white of the paper. Dip a sponge into the bowl of water and gum arabic solution and squeeze it out over the photocopy (figure 7). Remove the excess water by blotting the image with a sponge. The solution will push the excess ink from the bare paper areas of the image towards the inked areas or onto the surrounding glass (figure 8). Then repeat the process three to four times. Apply ink again with the brayer, then clean off the excess using the water/gum arabic solution and sponge. Washing out will not remove the ink that adhered

Studio Ceramics

Positive & Negative, 12 inches in height, porcelain vessel with photo transfer printed images, cone 6, Kristina Bogdanov

Lithography Old & New

Lithography, which literally means "writing on stone," makes use of the fact that grease and water do not mix. Invented as a lucky accident in 1798 by Alois Senefelder who wanted to switch from printing from expensive copper plates, the technique consists of drawing with a grease pen or other water-repellent material on a porous limestone block. The drawn on areas accept an oil-based ink while the bare stone does not.

Don Santos was the first ceramist to recognize that a photocopy behaves like a greased lithography stone. He developed this printing process, known as "viscosity transfer."

to the black of the photocopy, since water and oil don't mix. These areas will build up a thin layer of ink each time you repeat the process, so your final print will have even, solid lines and blocks of color.

Transfer the Image

The next step is to lift the inked paper and press it onto the clay surface. Lift the paper with great care, since it's very moist and will rip easily (figure 9). The best printing qualities are obtained when you print on moist to leather-hard clay. Bone-dry clay does not absorb the image as well. If the clay is too soft, the combination of inked and wet paper on a moist surface will cause the image to smear. Once you've placed the paper on the clay surface (figure 10), press it down gently with a damp sponge so it adheres to the clay (figure 11). As the paper starts to dry, use the back of a plastic spoon to buff and further compress the image into the clay. When the paper is completely dry, it easily removes from the clay (figures 12 and 13).

Finishing

Once your pieces are dry, bisque fire them to the recommended temperature. Be careful not to touch the image, even after the bisque firing, since the stains can be smeared. Spray or dip the piece in glaze for the best results. The image becomes permanently fixed onto the surface only after the glaze or high-temperature firing.

The advantages of the photocopy lithography process are numerous. It's a very cheap and easy way to transfer photographic images onto a variety of objects, from tiles to vessels to sculptures. The image is transferred after the paper is wet and flexible, which offers you the possibility to print not only on flat slab surfaces but on concave and convex surfaces as well. Since the inks are mixed from Mason stains and applied on greenware, it's very integrated into the actual ceramic firing process, and the image is durable and permanent once the piece has been glaze fired. The process does not use solvents, and so is a nontoxic process that does not require special ventilation.

Easy Image Transfer

by Paul Andrew Wandless

Image on a hi-res screen by Chicago artist Tom Lucas, used to print on clay.

Screenprinting ranks as one of the most popular printmaking techniques because it can be used to apply images to virtually any surface.

Clay artists are always looking for simple options to transfer complex images, designs, patterns, digital images and photography onto their ceramic pieces. While many image transfer techniques, such as decals, require chemicals and equipment, I've discovered a simple, commercially available screen that requires minimal effort to create an image for printing. The product is called PhotoEZ (available at www.ez-screenprint.com) and it's designed for use with simple black and white photocopies and the sun. You can go from an idea to screening an image on clay in about an hour! How cool is that?

PhotoEZ is a screen that's pre-coated with a light-sensitive, water-soluble polymer. Instead of using a light table to expose an image into the emulsion, you simply use the sun as your light source to expose the screen for about 5 minutes then soak (develop) the screen in tap water for about 15 minutes. After the exposed areas have been hardened or "set" during the soaking, rinse the screen with water to wash away the unexposed emulsion and create an open, stencil version of your image.

The final step is putting it back in

Studio Ceramics

1 Peeling protective covering off the screen.

2 Black felt covered board, screen centered over photocopy placed on Plexiglas and fastening clips.

the sun for another 15 to 20 minutes to harden the emulsion and make the screen more durable. Experiment with the test strips included in the kit to get the hang of exposing and setting the screen before using a full sheet for your final image.

Image, Paper and Screen

For best results, the type of image, screen mesh size and photocopy paper must be suitable and compatible with each other. Though your image can be simple or complex, it must be black and white. It can be line art, an illustration, photograph, digital image or halftone. Line-art images have few, if any, small details and consist more of bold lines and shapes or silhouettes with high contrast and no mid tones, so those are considered simple images. Illustrations, photographs, digital images or halftone images that typically have finer lines and smaller details are considered complex images. (Note: If the line or image parts are too fine or small, the screen will clog when printing.) Once you choose an image, make a black and white print or photocopy using paper that is no more than 20-pound weight and has a brightness rating of 84 or less.

PhotoEZ screens come in two mesh sizes for simple or complex images. The Standard screen is 110 mesh and the Hi-Res screen is 200 mesh. The 110 mesh has larger openings and is best for simple images, while the 200 mesh is a tighter screen (with more threads per square inch, resulting in smaller openings) and is best for the more complex images. Both screen meshes come in a variety of sizes.

The image in figure 1 started with digital photographs of tools in my studio, which were altered in Pho-

3
Rinsing screen to remove unexposed emulsion.

4
Dabbing off extra water from screen.

toshop to make them high contrast black and white images. You can arrange the images on the screen in a group, leaving half-inch spaces between individual images for easier printing. You can also fill the screen with just one image, a pattern, motif, text or any combination of these. I printed on a 8½×11 in. sheet of paper using an HP laser printer.

Setting up the Exposure Frame

With the black and white image on paper, you're ready to set up the exposure frame. Everything needed is supplied in the PhotoEZ Starter Kit—one 10×12 in. exposure frame (black felt-covered board with clips and Plexiglas), two sheets of 8½×11 in. Standard PhotoEZ screens (110 mesh), small test strips, one plastic canvas and a small squeegee. Tip: Work in a dimly lit room while setting up the exposure frame to avoid prematurely exposing the screen.

Remove the protective covering from both sides of the Plexiglas and place it on a flat surface, then align your black and white image in the center. Take one of the PhotoEZ screens from the protective black envelope then close the bag tightly so the unused screen inside is still protected. Peel the protective backing off the screen (figure 1) and immediately place it shiny side down on top of the black and white image (figure 2). Place the exposure board on top of the screen with the black felt side down and clamp together with the clips provided in the kit.

As soon as you're done, take the frame out into the sunlight. Keep the Plexiglas side down to keep light from hitting it or cover it with a towel to protect it from light before and after exposing it to sunlight.

Exposing and Setting

Once outside, turn the exposing frame Plexiglas side up to face the sun. Expose for 5 minutes during a regular sunny day and for 6 minutes if it's a slightly overcast day. Dark, cloudy days with no real sunlight are not optimal and success varies if exposed under these conditions. I exposed this screen for 6 minutes on a partially cloudy day, but had good sunlight through the light clouds.

Once exposure is complete, turn the frame over (Plexiglas side down) or cover with a towel and go inside to "set" the screen in a dimly lit room. Unclamp the frame and submerge the screen in a sink or container filled with cool water for a minimum of 15 minutes to develop your stencil. Soaking longer than 15 minutes doesn't harm the stencil in any way. After a minute or two, the unexposed areas blocked by the dark parts of your image appear light green. The exposed areas turn dark, and these darker areas become the stencil.

After 15 minutes, place the perforated plastic canvas provided in the kit under the screen and rinse with cool water from a faucet or kitchen sprayer (figure 3). The plastic canvas acts as a protective backing for the screen during the rinsing process. Rinse both sides of the screen to remove the unexposed emulsion (light green areas). Take more care when rinsing the side that the emulsion is applied to. Keep rinsing until all the residue from the unexposed emulsion is completely removed. Use a soft nylon brush if there are some small detail areas that did not rinse out well. This happens more with complex images in the Hi-Res screens because of the tighter mesh.

When done rinsing, hold it up to the light to check it. You should only see the white threads of the screen itself in the open areas. If you still see a thin film of residue, rinse again. After completely rinsing, place the screen emulsion side up on a paper towel and dab off all the excess water (figure 4). Put a fresh dry paper towel under the screen with emulsion side up and take it outside to re-expose in the sun for 10–20 minutes. This hardens the stencil and makes it more durable and longer lasting.

Using the Screen

Once the screen is hardened, you're ready to use it! Since the screen is unframed, it's flexible and can be used around a vessel or on a flat slab. Any surface you can bend the screen around is fair game to print your image on. Be careful not to make creases in the screen if you try to bend it around sharp corners. This will keep it from lying flat if you want to print on a flat surface in the future. If you group them onto one screen, you can also use scissors to cut it into smaller individual images.

Experiment and have fun with this easy to use product. It's a great way to create images for screenprinting on clay that you thought were only possible with a darkroom. You can screen images directly onto greenware, bisqueware or decal paper using both underglaze and glaze.

Fumiya Mukoyama
Zogan Yusai

by Naomi Tsukamoto

Studio Ceramics

Inlaid geometric slip and glaze designs inspired by the sun, waves and sea spray give Fumiya Mukoyama's works individual character.

Japan is filled with pottery and potters, and traditionally their styles have been regionally classified. If you are a young ceramic artist living in one of these kamamoto (literally translated as "by the kiln") towns, your challenge is to break out of the tradition and become recognized for your own style. Fumiya Mukoyama lives and works in the Mashiko region, where Mingei is their signature style. For many years, he has practiced to perfect the zogan yusai technique on his wave and geometric patterns. Zogan means inlaid, and yusai means coloring with glazes. Having been trained in Kyoto as a tea ware maker, his forms are extremely precise and pristine. But the patterns he creates and the combinations of glazes and stains he paints add warmth and organic tones to his forms. When asked how he got into this highly technical and meticulous surface design, he said it started with the sea spray he saw at dawn. In order to paint the sun, waves, and the ocean with glazes, he began using an inlaid technique to emphasize the separation of colors. Here he created a typical Japanese rice bowl to demonstrate his one-of-a-kind zogan yusai technique.

Ceramic Arts Handbook

1 Use a tombo to create vessels that are the same height and diameter.

2 Create a rounded, mushroom shaped chuck so you can trim the piece all the way to the rim.

3 A surface gauge is used to determine the height of the foot.

4 U-shaped gauge with one point at the center of the foot and the other marking the outer diameter.

5 Draw drafting lines with calligraphy ink, dividing the surface into vertical and horizontal sections.

6 Create a circular incised shape in the surface of the bowl using a medicine bottle top or other tool.

Throwing and Trimming

Mukoyama uses several different tools and techniques to create multiple pieces of the same size, and to create a clean surface for his designs.

He throws the tea bowls off the hump, starting with a large lump of clay, centering it into a wide cone, then shaping, centering, opening, and then throwing an appropriate-sized portion of the top section of this cone.

When throwing off the hump, be sure to thoroughly compress the bottom interior of your vessel to prevent S cracks. As Mukoyama throws, he uses the curve on the wooden rib to determine the inside shape of the bowl.

The tombo is a depth and diameter gauge. The one shown here (figure 1) consists of two pieces of wood joined perpendicularly, with a thin

7 Etch or incise the dotted lines using a fabric rotary cutter or pizza cutter.

8 Use a soft brush to lightly pat the kaolin slip into the pattern of incised lines and dots (figure 10).

9 Once the slip dries, rub it in to the lines further with your fingers. It will be very powdery once dry.

10 Wipe off the surface lightly with a cheese cloth like fabric. The slip inlay lines will show clearly on the surface.

11 After the second bisque firing, mask off the lines within the circular areas so they will remain white.

12 Filling in each patterned circle with different glazes, metallic oxides and underglazes.

bamboo dowel cut to exactly the desired diameter of the bow that slides through a hole in the lower piece of wood. The piece inserted into the bowl is exactly the right height so that it touches the bottom of the bowl when the dowel marking the proper diameter rests on the rim of the bowl. Once you decide on a height, and cut the thin dowel to the desire diameter, you can create many pots of the same size.

After you finish throwing, cut the pot off the hump. Be careful to mark a line first so you don't cut through the bottom. After the piece is leather hard, you're ready to trim.

When trimming, use a chuck so that the form can be both well supported so that it does not warp, and

elevated from the wheel head so that it can be trimmed all the way to the rim. If you don't have a chuck already, throw a somewhat mushroom shaped solid form with a slight concavity and beveled top edges on a bat or on your wheel head like the one shown here (figure 2) and leave it attached. Once it is leather hard, it is ready to use.

Before trimming, use a surface gauge to determine the height of the foot (figure 3). This is especially necessary when throwing off the hump as the cuts made when removing each piece from the wheel may not result in a bottom with the same thickness each time.

Once the foot is trimmed to the proper height, the U-shaped gauge is used to determine the width of the foot (figure 4). The foot is then trimmed to this diameter. The next step is to trim the piece from the bottom all the way to the lip of the bowl, both to remove excess clay and to remove throwing lines and create a smooth surface. In order for the inlaid design to come out clearly, it is important to make the surface as smooth as possible at this stage. Mukoyama ends the trimming by going over the surface with a sponge, erasing all the trimming lines. Finer clay works better for the zogan technique. A rubber or metal rib would work if you are using coarser clay.

Drafting and Etching Design

In order to determine where the circular patterns will be placed, Mukoyama draws drafting lines with calligraphy ink, dividing the surface into six sections (figure 5).

The tools used to create geometric shapes do not have to be fancy. Here a medicine cap is used for the circular pattern (figure 6). The lines on the cap help him to line up the circle vertically and horizontally with the lines drawn on his pot.

Clean and round the edges with a trimming tool after etching the design. After making the etched lines smooth, go over the lines with the needle tool to round inside of the lines.

A fabric rotary cutter (could be replaced by a pizza cutter) is used to etch the dotted lines (figure 7).

Zogan

Because the slip is only inlaid inside the lines, Mukoyama uses watered down pure Amakusa Porcelain Stone powder, which is equivalent to Cornwall Stone. This simplifies cleaning the surface later. This slip will not work for painting the surface though, because once dried, it is powdery and will flake off easily.

The slip should be quite watery, much thinner than the normal con-

sistency, in order to fill in the small dots. Use the brush to lightly pat in the slip (figure 8). Once the slip dries, rub in the slip further using your fingertips (figure 9).

Normally, you would scrape the surface in order to finish the slip inlay; however, since the slip was pure clay, all you need to do is to wipe off the surface lightly with a cheese cloth like fabric (figure 10). Be cautious not to wipe the surface too hard, otherwise, you will lose the inlaid lines. The more clearly you can maintain the division between the inlay and surrounding surface, the more vivid the final colors will be. After cleaning the surface, bisque fire the piece.

Glazing the Background

Once bisque fired, make sure you clean the ware with a wet sponge first in order to achieve the best glazing result. Brush wax resist on the circular patterns. Mukoyama usually covers the lines with water-based latex resist using a very thin brush first, and then fills inside the design with melted wax mixed with kerosene using a small brush. Using latex on the lines ensures that the resist can be removed and reapplied if it is covering more than just the incised lines and patterned areas.

After the resist dries, glaze the inside by pouring first, then dip the base glaze outside. Wipe any glaze off of the circular design areas and clean any drips on the foot ring before the second bisque firing. The purpose of the second bisque firing is to burn off the resist and to fire on the base glaze.

Yusai

After the second bisque, only mask off the lines (figure 11). You will want to fill in the rest of the area using colorants and glazes. Because some glazes do run, it works better if you mask a little over the lines rather than precisely covering only the lines.

Fill in each pattern with different glazes, metallic oxides, and underglazes. Mukoyama only uses two colors for each pattern to achieve the unified balance (figure 12). You could also leave some parts bare to take advantage of the clay color. Glaze from lighter to darker colors as you work to keep them from contaminating one another.

This is the last glazing step. Think of glazes and stains as colors and carefully consider the color balance for each circular pattern and between the patterns. Also consider the type of finish (glossy, matte, and dry) you combine. Depending on how you combine the linear patterns and colors, you will find numerous design possibilities in zogan yusai.

Materials and Firing

left to right:
1. imari gosu cobalt pigment & iron matte glaze
2. red underglaze & white matte glaze
3. titanium dioxide & iron glaze

4. imari gosu cobalt pigment & white matte glaze
5. bengala iron pigment & titanium glaze
6. iron glaze & white matte glaze

Recipes

Clay
Shigaraki Namikoshi Stoneware	100 %
Add: Bengala Iron Pigment	2 %
Manganese Dioxide	2 %

Inlaid Slip
Amakusa Porcelain Stone	100 %

Mix with water until thinned

White Matte Glaze
Fukushima Feldspar	57.0%
Gray Limestone	31.5
Ball Clay	11.5
	100.0%
Add: Zirconium Silicate	10.3%

Iron Matt Glaze
Fukushima Feldspar	57.0%
Gray Limestone	31.5
Ball Clay	11.5
	100.0%
Add: Bengala Iron Pigment	1.0%
Manganese Dioxide	0.3%

Titanium Glaze
Fukushima Feldspar	65.0
Gray Limestone	8.0
Titanium Dioxide	14.6
Zinc Oxide	12.4
	100.0%

Iron Glaze
Clear Glaze	100.0%
Add: Bengala Iron Pigment	7.5%
Manganese Dioxide	2.0%

Pigments for Geometric Patterns
Imari Gosu Cobalt Pigment (Gosu is a commercially available product in Japan. Where this is not available, substitute Cobalt Carbonate or blue Mason Stains.)

Bengala Iron Pigment

High Fire Red Underglaze

Titanium Dioxide
Bisque firing is done in a gas kiln, to 1292°F (700°C) in 8 hours.

The glaze firing is done in oxidation in gas kiln to 2264° F (1240°C) in 15 hours.

SUBSTITUTIONS

Make the following substitutions for the Japanese glaze materials. Test all substitutions and adjust as needed.

Shigaraki Namikoshi Stoneware
Substitute: Fine Grog White Stoneware

Amakusa Porcelain Stone
Substitute: Cornwall Stone

Fukushima Feldspar
Substitute: Custer Feldspar

Gray Limestone
Substitute: Whiting

Bengala Iron Pigment
Substitute: Red Iron Oxide

How to Create Agateware

by Michelle Erickson and Robert Hunter

Semiprecious stones such as agate were prevalent as design elements in Chinese, Greek, and Roman societies and often associated with nobility. The use of multiple colored clays to imitate agate can be traced to antiquity. Beginning in the late 17th century, this technique was used to fashion a class of English ceramics generally known as agateware.

English agateware has been made for useful and ornamental purposes, collected, and written about for centuries. However, only limited discussions of production methods have been published. Our approach to decoding and recreating English agateware began with the examination of antique specimens and archaeological fragments.

Agateware can be divided into two broad categories: thrown agate and laid agate. Thrown agate describes a vessel formed on a wheel using a prepared mixture of various colored clays. We'll be focusing on laid agate, which refers to an object created from a thin sheet or slab made of agate clay. This thin sheet is draped

Michelle Erickson's "Dragon Junk," 12 inches in height, press molded and wheel thrown, colored porcelains, indigenous clays, cobalt underglaze decoration.

Dragon Junk

The title of this piece, which is in the collection of the Yale University Art Gallery, refers to the artifacts excavated from the Chinese junk ships that sunk in the process of exporting 'China' to the Western world. Conceptually, it speaks to objects changed by time through their environment. The jade-like agated copper porcelain here also speaks to a geological phenomenon of precious stone associated with the east to further the reference of crossing time and culture. The double entendre of the pecten shell form for the teapot mirrors its environment on the ocean floor. —Michelle Erickson

Studio Ceramics

Footed censers, agateware, 3 inches (8 cm) in height, China, Tang Dynasty.

nized for his improvements in agateware undertaken in the 1740s, including the use of white clays stained with metallic oxides. Still, a firm date for the beginning of laid agate in Staffordshire has yet to be established. Beyond the date of its introduction, however, the source of the laid agate pattern is perhaps the more important inquiry. For us, it is clear that 8th-century Tang dynasty Chinese wares inspired many 18th century Staffordshire laid agatewares. The relationship is most obviously visible in the form of globular censers, or incense burners, which are of the same size and shape as the Staffordshire teapots.

The imitation of 8th-century Chinese ceramics by Staffordshire potters is not as improbable as it may seem at first. It is known that contemporary Chinese porcelains and Yixing stonewares served as direct prototypes for many 18th-century Staffordshire tea wares. It is likely that older Chinese wares resided in European and English antiquarian collections. Such antique wares were sought for the "cabinets of curiosities" of the English cognoscenti. Intriguingly, the cabinets belonging to these scientifically minded collectors often included "agates, onyxes, and intaglios."

In 1754, Whieldon entered into a partnership with young Josiah Wedgwood. Excavations at Whieldon's manufactory at Fenton Vivian revealed a number of laid agate wasters, which appeared to have been manufactured during the period of the partnership. One of the most often cited agateware references comes from Josiah Wedgwood's experiment book on March 23, 1759: "I had already made an imitation of Agat which was esteem'd very beautiful, and a considerable improvement…" Just how much he improved the agateware process and whether he had a direct hand in copying Chinese prototypes is undocumented.

Preparing the Clay

Making agateware is a complicated process; the marbling, instead of being produced on the surface, goes

Studio Ceramics

1. Colored clays: (front) uncolored white earthenware; (back) iron oxide, manganese oxide, cobalt carbonate.

2. Lay a slab of iron enriched red clay onto a base white clay of the same dimensions but three times as thick.

3. Throw the combined slabs down onto a hard table surface to stretch and thin the layers.

4. Cut the clay slab in half and restack the two pieces. Repeat this process of adding and thinning the layers.

5. The combined clay slab after cutting it the second time reveals the alternating layers.

6. Cut the slab in half after repeating the stacking and thinning steps shown in fig. 3 to 5 several times.

through the body and it requires a different set of skills other than just competent throwing. The initial preparation of clay is the key for creating laid agateware (figure 1). If using naturally colored clays, do tests first to be sure the clays are compatible. The shrinkage rates and firing temperatures need to be the same. Additional considerations include the density, plasticity, elasticity, and strength. The clay slabs are first stacked in a selected sequence (figure 2). Rather than wedging, the stacks are slammed onto a hard surface to elongate and consequently thin the slabs (figure 3). The process continues with cutting and restacking the slabs, thinning and increasing the numbers of layers (figures 4, 5, and 6). The ultimate success of the agate patterning lies in the care taken at this initial stage. If you want more colors in your agate pattern, the three color clay slabs can be prepared in the same way. Once the layered slabs are made, they are trimmed to equal rectangular sizes (figure 7).

Piecing Together a Pattern

After these slabs of thinly layered clays are prepared, they are rolled into tight coils (figure 8). These

7 Trim the layered slabs to equal rectangular sizes.

8 Roll one end of each slab into a coil, and cut from the slab.

9 Arrange the rolled coils by alternating the colors.

10 Press the rolled and alternating coils into a solid cylindrical mass approximately 3 inches in diameter.

11 Square off the mass and cut thin layers from the stack, revealing the beginnings of the agate pattern.

12 Arrange and carefully push the layers together on a flat surface, alternating the patterns.

coils are then arranged, sometimes by alternating colors (figure 9), and carefully pressed into a single mass (figure 10). From this amalgamated mass, thin slabs are then cut and arranged on a flat surface to begin forming a sheet (figures 11 and 12). At this point, the outcome of the agate striations can be controlled by the placement of the slabs. Once a reconstituted clay sheet is made (figure 13), it is cut into strips and reassembled to emulate the arbitrary nature of the agate pattern (figure 14). Examination of antique pots suggests that such strips were cut and rearranged several times on both a horizontal and vertical plane or orientation. In working through this technique, it is clear that a number of variations are possible through the deliberate arrangement of the agate pattern.

For the demonstration, the patterning of the agate has been left moderately coarse so that is it easily observable in the photographs (figure 15). The slab is now usable.

Creating the Forms

Once a suitable agate pattern is created, the thin sheet of clay is ready for molding. In most cases, it appears that all elements of laid

Studio Ceramics

13 Join and flatten the layers using a rolling pin. Use a sheet of paper to keep the pattern crisp and intact.

14 Cut horizontal strips from the flat slab, rearrange them to accentuate the pattern, and roll out to rejoin.

15 Cut vertical strips and roll out again to rejoin to create the agate slab checkerboard pattern.

16 Lay the thin agate slab into the plaster press mold.

17 Press the slab firmly into the recesses and corners of the mold.

18 Several two piece molds are necessary for producing a form like a teapot.

agateware were created by press molding (figures 16 and 17). This process requires a separate plaster or clay mold for each component of a pot. This would include the body, foot rim or feet, lid, finial, spout, and handles. As with the thrown agate, joins may show smearing, or distortion. The teapot shown here uses two-piece molds for the pecten shell body, spout, handle, and Fo Lion finial (figure 18). These molds were taken from original master models sculpted by Michelle Erickson.

Once the two halves of each part of the teapot are pressed in separate molds, they are ready to be joined. The edges are lightly scored and moistened. The two molds are aligned, and the seam is closed by working from the inside through the opening in the neck (figure 19). The exterior seam is cleaned up, then the spout, handle, and any other added elements are attached to the body (figure 20). For lidded forms, keep the lid on during the drying process. If necessary, line the rim or gallery of the pot or lid with a sheet of paper to keep the two from sticking together. Once dried, it is possible to enhance the agate surface with a light scrubbing using the equivalent of a fine steel wool; however, any heavy

19 Score and moisten the edges, align the mold, press halves together, and close the seam from the inside.

20 After removing the forms from the molds, clean the seams, assemble the parts, and allow the piece to dry.

Teapot, Staffordshire, 5$\frac{1}{8}$ inches (13 cm) in height, lead-glazed agateware, 1745–1755. An example of a press-molded pecten shaped teapot serves as the prototype for the demonstration of the laid agate techniques. Note the seemingly naturalistic patterning of the laid agate which exhibits alternate squares of cobalt colored clay.

smudging or distortion cannot be altered. Once dry, the pot is bisque fired, glazed, and fired again.

Conclusion

A rich opportunity exists to further study the production history of English agateware. The laid agate technique is an extremely complicated procedure. Indeed, the replication of the processes presented here required nearly two years of trial and error research.

For laid agate, although the patterning is often described as random, we have concluded that it is very deliberate. This deliberateness can be seen in a variety of other agate patterns that have yet to be fully classified.

Without question, agateware can generate a kaleidoscopic effect that some may find dizzying. A fierce competition for antique examples exists among a small cadre of collectors—past and present. Perhaps this fact alone substantiates the often heard claim that agateware is considered "the ultimate refinement of the potter's art." We hope this demonstration has provided some insight into the mysteries of the potter's art and that new research on the history of agateware can be conducted with fresh eyes.

Studio Ceramics

Cream jug, Staffordshire, 10 inches (25 cm) in height, lead-glazed agateware, ca. 1750. Note the alternating checkerboard pattern of the agate strips.

Detective Work
by Michelle Erickson

Deciphering the technique of 'laid agate' used by the Staffordshire potters in the 18th century was done over the course of four years. It's important to note that I gained most of these insights through direct physical interaction with the artifacts and photographs and not through any written descriptions or formulas. The material published here was not available at the time. It has also been my experience that though published material exists, speculative theories on early production methods rarely bear results in practice.

My work in rediscovering this particular technique began by examining original pieces when possible and using photographs while in the studio to start unraveling a series of complex steps; essentially working backwards from the finished piece to its original raw components. This led to formulating a palette of compatible colored earthenware's to match the original fabric, using metallic oxides in various proportions to achieve what appeared to be three alternating colors, variegated with the base white earthenware. I used cobalt, manganese, and iron oxides to approximate not only the original color but the bleeding or blurring effect present in the originals, neither of which can be achieved with the addition of commercial stains to the base clay or commercially-produced colored clays.

I created a "creamware" glaze that would give me the fit, translucency, and hue of the original wares, which took time to achieve. Simultaneously, I began measuring and studying the proportion and design of the specific antique pecten shell teapot example illustrated. In order to proceed, I modeled the original artwork for the teapot and each component in clay accounting for shrinkage and cast separate two-part plaster molds for the teapot, spout, lid and finial. The idea that these wares were molded was generally accepted but the way in which press molding preserved the integrity of the pattern became key to the eventual success of the whole process.

Beyond the molded components was the complex composition of the agate itself, I could achieve random agate patterns relatively easily but it was the challenge of defining a method for this specific agate that allowed for my insight into a technique that has proven to elude many scholars and practicing ceramic artists. Each stage revealed a breakthrough only through trial and error experimentation and gradually the elegant solutions, though labor intensive, began to emerge.

Thrown Agateware

by Michelle Erickson and Robert Hunter

Studio Ceramics

Factory of John Dwight, England (Fulham), 1670-1859. Covered Tankard, ca. 1685-1690. Stoneware with salt glaze, 10½ inches (27 cm) in height. Photo courtesy the Nelson-Atkins Museum of Art, Kansas City, Missouri. Gift of Frank P. Burnap, 55-77 A, B.

Beginning in the late seventeenth century, a prepared mixture of various colored clays that mimics the variegated appearance of agate stone was used to fashion a class of English ceramics recognized as agateware. There are two types of agateware, one is wheel thrown and the other is made using handbuilding techniques, and is classified as laid agateware.

Background

The earliest English thrown agate is found among the products of John Dwight (even though he himself referred to it as marbled). Considered by many as the father of English pottery, Dwight is well known in the annals of ceramic history for his innovations. He conducted numerous ceramic experiments beginning in the 1670s, delved into the mysteries of porcelain, and recorded his recipe to produce "marbled" stoneware.

Dwight's notes reveal two important material considerations in making an agate body: clay color and clay compatibility. To create the illusion of agate striations, different color clays must be obtained naturally or by modification, adding pigments or coloring agents. The tone of a natural clay can also be altered by sieving to remove impurities such as iron and sand.

Creating a successful variegated appearance also depends on the proportions of clay colors used. Clues for understanding problems related to combining multiple clays are also contained in Dwight's formula.

Ceramic Arts Handbook

1 In preparing the clay for throwing an agateware mug, slabs of varied colored earthenware clays are cut and stacked.

2 The slabs are then stacked in alternating colors. After the initial stacking, the clay is sliced in half and restacked.

3 The clay is carefully wedged or kneaded to prepare it for throwing.

4 This ball of clay has been cut in half as an example of the pattern prior to throwing.

5 The cylinder is shaped into the final mug form. Note how the muddy surface has concealed the agate patterning.

6 A cross section of a thrown cylinder shows distinct lines and swirls of the colored clays.

These include shrinkage rates, firing temperatures, density, plasticity, elasticity, and strength. All of these properties must be considered when mixing dissimilar clay bodies.

Today, only a few of Dwight's "marbled" or agatewares survive. In addition, some agateware fragments have been recovered from archaeological excavations of his pottery site in Fulham, England. These fragments include examples of a tankard, a gorge (or mug), a cappuchine (coffee cup), and a teapot. It is hard to judge whether Dwight's agateware was received as a novelty or as an important scientific discovery.

Commercial production of English agateware began in earnest in the second quarter of the eighteenth century. In 1729, Samuel Bell, at the Lower Street Potworks, Newcastle-

Studio Ceramics

7 Final contours are shaped using a metal rib, and the slip covering the exterior is scraped away, revealing the agate pattern.

8 Final finishing of the base of the thrown mug.

9 Interior of the mug being scraped to reveal the agate pattern.

under-Lyme, was granted a patent to produce "red marbled stoneware with mineral earth found within this kingdom which being firmly united by fire will make it capable of receiving a gloss so beautiful as to imitate if not compare with ruby." Like Dwight's agate, the Bell products were thrown on the wheel. After being initially formed, the wares were turned on the lathe to thin the body and concurrently create a clean variegated surface. These wares typically had a red and off-white clay body even though a black colored clay was used.

Archaeological evidence from the excavation of Staffordshire factory sites, including that of John Bell and of John Astbury at Shelton Farm, shows that many potters made this type of thrown agate. Tea wares were the most common forms made, although mugs and bowls were also produced. Thrown agate reached the height of its popularity in the 1750s and continued in production into the early 1770s.

A number of nineteenth-century American potteries used agate clays to manufacture doorknobs covered with a Rockingham glaze. In the twentieth century, agateware makes a brief appearance in the arts and crafts movement, most notably in the "Mission Swirl" line of the Niloak Pottery Company in Benton, Arkansas. Another thrown agate of this general type was produced by North State Pottery of North Carolina in the 1920s and 1930s.

Making Thrown Agateware

The key step in creating an agateware body is preparation. For creating thrown agate, the initial selecting and mixing of clays is critical. Three colored earthenware clays were selected: a white clay, a red iron clay, and an iron manganese body (figure 1). Tip: You could also start experimenting by using only

one light colored clay body and adding commercial stains or oxides to create three different colors.

To begin, clay slabs are built up, alternating the colors (fig. 2). This stack is then wedged or folded to form a ball that can then be thrown on the wheel (figure 3). Care has to be taken during wedging to ensure the clays are mixed without overly distorting or blurring the resultant agate pattern. For demonstration purposes, the wedged ball is cut to show the pattern prior to throwing (figure 4). The degree of success in an agate pattern comes from the initial wedging process as well as the throwing.

The prepared clay ball is then centered on the wheel (figure 5). Once centered, the clay ball is opened and pulled quickly into a cylinder. During throwing, the surface of the clay body becomes smeared so that agate patterning is obscured. Care has to be exercised during throwing so as not to overwork the clay; otherwise, the pattern becomes muddled. This test piece was cut in half to show how the agate patterning shifts in the cross section of the clay wall. The different colors should remain distinct (figure 6). Since nearly all Staffordshire thrown agate was subsequently trimmed on the lathe, the veining usually appears sharp and crisp. Later smearing and smudging can occur at the attachment points of handles or spouts as evidenced on some antiques.

Most potters don't have a lathe, but the pattern can be revealed by using a metal rib (figure 7) to scrape away the slip and outer layer of clay from the surface. Using a shaped rib or the metal rib again defines the foot or base while maintaining a crisp pattern (figure 8). Lastly, scraping the interior of the form reveals the agate pattern on the inside (figure 9).

Studio Ceramics

Marbled Slipware

by Michelle Erickson and Robert Hunter

Left: Marbled dish, Italian slipware, ca. 1620-1640 (from the Chipstone Foundation collection). Right: Dish, Staffordshire or Midlands, 1720–1750; slipware, 13¾ inches in diameter (Image courtesy of the Colonial Williamsburg Foundation).

For thousands of years, potters in many cultures have used slip or liquid clay to create decoration. The technique was elevated to an industrial level in seventeenth-century Staffordshire, England where potters produced a wide variety of dishes and hollow wares for the international market. American archaeologists unearth English slipware fragments in prodigious quantities from seventeenth and eighteenth century historical sites. Contemporary art potters have also found inspiration in these traditional English slipwares, popularized by the work of Bernard Leach and his students.

The creation of marbleized patterning where two or more colored slips are laid down and manipulated to produce a variegated appearance is among the most common slipware decorating techniques. The English technique of marbling may have had its origins in the early seventeenth-century marbled slipwares of Northern Italy (above left). Early American slipware potters working in many parts of the colonies also employed marbleizing methods in decorating their wares (above right).

How It Works

Gravity and centrifugal force are key elements for inducing the movement or flow of the slips during the marbleizing process. The term "joggling" is used to describe the physical act of controlling this movement

which requires very specific, and somewhat awkward looking, body and arm movements. The degree of aesthetic success is directly linked to the skill of the potter in controlling the flow of the slips. It is interesting to note the words of Bernard Leach who suggested turning slip-trailing mistakes into marbled decoration: "When one or more slips have been unsuccessfully [emphasis added] trailed over a wet background,…it is sometimes a good plan to try for a marbled effect by violently shaking and twisting the board upon which the clay rests." Leach's assertion implies that the mixing of two or more colors of slip to produce marbled patterns seems a fairly random and haphazard process but the opposite is true. It actually requires a thorough mastery of the materials and physical control of the slips.

Understanding the nature of slip is important as its properties can vary from one extreme to the other. When using slip, the clay particles tend to fall out of suspension fairly quickly so that the potter needs to frequently stir the solution as it has a very short working life. As soon as slip comes into contact with a drier surface, it begins to stiffen immediately. It is analogous to working with molten glass. Unlike glass though, slip can not be "reheated" or remoistened. A mistake made in applying a slip means living with it or wiping it off and starting over.

Tools, Techniques and Materials

The essential tool needed for slip trailing and marbleizing was (and still is) the slip cup. The trailer itself was a small, clay vessel although leather, fabric or animal horn may have also been used. The concept of the trailer was simple. A small tube, reed or quill was inserted into the trailer, which would be filled through a top hole. The potter could regulate the flow of the slip by covering the top hole that also served as a vent. In order to flow freely, the viscosity of the slip had to be maintained through frequently shaking, and adding water or a thicker slip mixture throughout the process

In most instances, slip is poured or dropped onto another surface. Rarely is it brushed on; the clay surface is usually damp, which causes the slip to be streaky or uneven. Although brushing can produce very accurate lines, it also necessitates building up several layers to achieve a smooth surface. Pouring slip, however, instantly creates an even, opaque covering, making the best use of the materials and the potter's time.

The clays used for making the slips must have similar shrinkage and drying rates. The slips then have to be prepared with similar viscosity. Poorly prepared slips can produce an unsatisfactory flow and impede the marbling process.

The Process

The making of a Staffordshire style marbled slipware dish begins with a flat clay disk or slab rolled out to a consistent thickness. The slab is supported on a board or bat to bear the wet and still plastic clay.

1 Place a rolled-out slab of even thickness on a circular wooden bat. Flatten out and trim any overhanging clay. Holding the board, pour a black ground slip over the slab.

2 Immediately afterwards, trail parallel lines of white slip onto the wet ground. The consistency and moisture content of the slips must allow both to flow easily without running.

3 The marbleized slab in the process of joggling. Supporting the bat while rotating it to move the slip. The slips will firm up quickly.

4 The marbleizing process complete. The decoration is still on a flat slab. Before forming the vessel, the slips must be allowed to set up to prevent marring of the marbleized surface.

Pour a coating layer of slip over the slab, covering the entire exposed surface, allowing the excess slip to drain off (figure 1).

Immediately thereafter, trail a systematic series of lines in a contrasting slip across the entire surface (figure 2). Hold the tip of the slip tube above the surface as it should not touch the wet base slip. The distance between the tip of the slip tube and the surface of the ground slip dictates the width of the lines; the further from the surface, the wider the line.

Evidence from original examples like the Staffordshire or Midlands Dish suggest that the lines were laid down in very specific, proscribed pat-

5 The prepared slab immediately before joggling. Note how the white slip lines doubled back at the edge of the slab. This is key to achieving a pattern similar to the original dish.

6 The beginning of the marbleizing process. The slab, resting on the bat, has been rotated or "joggled" to start the flow of the slips.

7 After sufficient drying (when the surface is no longer tacky to the touch) the slab is draped over a hump mold and pressed into place to form the dish.

8 Finished and glazed marbleized slipware dish by Michelle Erickson, 13¾ inches in diameter, 2001 (from the collection of Judge Henry D. and Mrs. Kashouty).

terns which runs contrary to the suspicion that the marbling process used a more random application of slips. The edge of the original example is the key to determining the original configuration of the white slip lines. There is more white at the edges and patterns loop back from this point all around the piece, which indicates the series of lines was trailed on, one at a time, in a continuum within the confines of the slab disc, doubling back for each consecutive line (figure 3). This observation was critical to deciphering the trailing process employed by the 18th century Staffordshire potters to achieve this specific marbling technique.

After the slip lines are systematically applied, the clay slab, still supported by the bat, is then tipped and rotated using gravity to coax the slips to flow (figure 4). This process will create a pattern of swirls (figure 5). If the slip is too watery, the lines will run and blur. If the slip dries too quickly, the slips will not flow properly. Two conscious aesthetic and practical decisions have to be made: (1) how much time can be expended before the wet slips stop flowing; (2) how to judge when to stop before the lines of color lose their separation and become muddy. Because both slips tend to firm up quickly, the elapsed time for joggling is usually thirty to forty-five seconds.

The now marbled slab is set aside to allow the slips to dry further (figure 6). Before the vessel is formed, the slips must be allowed to set up to prevent marring of the marbleized surface yet the slab and the newly slipped surface must remain pliable. If the slab becomes too dry, it will crack. If the slips are still too wet, the slab will stick to the surface of the mold. After the slips are no longer tacky or wet to the touch, the entire slab, which is still plastic, is removed from the bat and placed over a "hump" mold surface down and pressed into shape (figure 7).

These molds were typically made of fired clay although a plaster one is being shown here. Allow the dish to dry further to a leather hard stage. The irregular edge is trimmed with a knife to form a completely circular form and the rim is then crimped or pressed with a coggle wheel to create a pattern. The molding process helps flatten the slips and after glazing, the surface is smooth (figure 8).

Further Exploration

In the case of most English flatware, the marbled or combed decoration is created before the form. Marbleizing on hollow forms takes place, however, after the vessel has been created, usually by throwing. The ground slip is either poured over the vessel or it is dipped into a container of slip. Contrasting colored slip is then trailed on, again in a systematic fashion. The vessel is then tilted and rotated to control the gravitational flow of the slip creating a variegation of the wet slips.

In addition to marbleized patterns, the same technique, without the joggling, can be used to create distinct images using contrasting slip. Slip is poured onto the surface then a design, image or pattern is trailed onto the wet surface. The slipware chargers above are examples of this technique.

Materials

As a ceramic artist my methodology is integral to my study of early ceramic techniques and the process of experimental archeology, using objects and fragments from ceramic history to rediscover the mysteries of the processes and materials used to create these wares. Obviously in the 21st century there are numerous commercially available materials to create a spectrum of palettes and glaze surfaces. For my purposes, however, I have chosen to develop all my own slips and glazes often using indigenous clays, metallic oxides, carbonates and sulfates and basic raw ceramic materials to create all of my glaze formulas as needed.

Suggested Clay and Slip

For cone 04 red earthenware, I use Standard's 103 (grogless) and 104 (with grog) clays and Laguna white earthenware (Miller 10) for slip decorated creamware and pearlware, which I also fire to cone 04. For slipware, a starting point would be to use your clay body (no grog) for a base. This way, you will be starting with slip compatible to your clay and glaze formulas. You can often buy dry bags of the clays you use and add various commercial stains to achieve the palette you want. I use metallic oxides, which tend to be more problematic but can offer rich results. Also, if you are looking to make a dark slip, start with an iron rich clay; it will require less colorant. Just try to find one compatible with the white or light clay/slip in terms of the firing range and shrinkage.

Tip

Do not use deflocculated slip (casting slips) for slip trailing and marbling, as the viscosity is counterproductive to this process.

Suggested Glazes

The piece I illustrated is a dark brown/black slip ground with a white slip trailed on top and the gold color of the finished piece comes from the addition of iron to the low temperature clear glaze.

There are many commercially available clear glazes and you can add a commercial yellow stain for the effect. I use iron oxide to give my own cone 04 formula its yellow gold hue to closely resemble the lead glazed Staffordshire slipwares. As I do not use lead on functional wares, I often use more temperamental ingredients that have small firing ranges and require a lot of experience in glazing and firing, so I am not including those formulas as they are not user friendly nor safe.

It is important to test fire new slips and glazes. I find my small test kiln invaluable and I will often take it up slowly and down fire it to more closely resemble the conditions in the large kiln. All my pieces are fired in Electric kilns but they do not self-fire and I do not use kiln sitters as my glazes are finicky and require manual manipulation of temperature.

Studio Ceramics

Emily Reason
Carving & Slip Trailing

by Katey Schultz

Serving bowl, 10 in. (25 cm) in diameter, thrown, carved and dotted porcelain, fired to Cone 10 in reduction.

Surface Decoration

Reason carves and slip trails her surface designs. The textures she creates are enhanced by the use of celadon glazes. She adorns the pot's surface at the leather-hard stage.

Reason's homemade carving tool was modeled after a tool used to create carved patterns on Chinese Yaoware pottery. The L-shaped blade, set in a bamboo handle, is used to create a pleated pattern of lines. For Reason, carving lines is a rhythmic motion that achieves even, consistent marks. The corner of the L, carves into the leather-hard clay, making the deepest part of the recessed line. The tool is effective in achieving a line with depth, allowing the glaze to vary as it pools in the deepest part of the line.

Slip-trailing bulbs and plastic bottles, such as hair-dye bottles with variously sized tips are used to create a dotted surface. Using her porcelain slurry, Reason sieves the clay to a yogurt consistency to make a thick slip. Dots of slip are squeezed onto the pot's surface with the bulb, much like decorating a cake. Both the carved lines and sharp tips of the dots are smoothed and softened with a damp sponge.

Teapot, 8 inches (20 cm) in height, thrown and slip-dotted porcelain, fired to cone 10 in reduction.

Salt and pepper shakers, 5 inches (13 cm) in height, thrown, carved and dotted porcelain, fired to cone 10 in reduction by Emily Reason.

Studio Ceramics

The Clay as Canvas

by Molly Hatch

I have always been interested in drawing. As an undergraduate, I focused on drawing for the majority of my time in school. It wasn't until my final year that I was shown surface decoration techniques for clay that are similar to printmaking and drawing processes. It was this marriage of drawing and clay that has driven the development of my current work.

There's something magical in the ability to interpret what I see through my hands. I think of drawing as a visual language similar to writing; both can be communication tools. I am often surprised by the small narratives that appear in the patterns I draw on the surfaces of my pots. Each bird has its own distinct personality and expression A moth will buzz around a peony. The patterns I draw are always my interpretation and representation of an already existing pattern. I sometimes combine elements of different patterns, in turn creating new patterns. I play with the scale of the pattern on the pot. How the pot frames the image often dictates the pattern itself.

I spend a large amount of time looking at historic fabrics as source material and I'm always collecting new patterns to add to my repertoire. I pull out new patterns when I need a challenge and I draw the pattern on paper a few times to familiarize myself with it before experimenting on my pots. I use porcelain for my work for its durability and translucence. I love the similarity of pure white porcelain to a blank piece of paper. My forms are inspired by contemporary product design, 18th century European factory ceramics as

Finch Cup with Baroque Frame, 13 inches (33 cm) in width.

1 When throwing, use the crook of your finger to shape the lip of a tumbler.

2 Laminated paper template of drawing can help maintain consistency in a design when transferring images to a set.

3 Gently wrap the laminated pattern around the cup and use a quill or pencil to trace the image.

4 Remove the template to reveal the transferred tracing image now impressed into the clay.

well as the English ceramics of the Leach/Cardew studio tradition.

Throwing a Blank Canvas

When I'm throwing, I think of the pots and their forms as that blank piece of paper. I strive to keep my forms simple, quiet, and uncomplicated. This simplicity allows the drawing to become the major focus of each pot, rather than a competition between form and surface.

The simplest and most popular pot I make is a tumbler form that I refer to as a beaker. I use about a pound of clay to make the beakers pictured in this article. When throwing, I use very few tools other than my hands. I use the crook of my forefinger and middle finger to shape the lips of my pots. When I do use tools, my favorite rib is a square rib fashioned after a Michael Cardew design and made for me by my husband who is a woodworker (figure 1). I'm careful to use the rib as little as possible because I enjoy the pots much more when there's evidence of my hand in them. When I'm trimming, I usually use a bat dampened slightly with a sponge. I tap the pot I'm trimming on center

Studio Ceramics

5 Use the transferred image as a guide for drawing deeper lines into the surface.

6 Finish off the rest of the drawing freehand, using the template as a visual reference.

7 Apply a layer of stained slip over the drawing using a wide brush.

8 Wipe the excess slip from the surface of the pot using a clean sponge.

and then, using the slightly damp surface of the bat, I apply pressure to the base of the pot, which creates a slight suction and secures the pot to wheel for trimming. When using this trimming technique, it helps to keep one hand on the pot at all times to catch it in the event that the suction gives way.

Image Transfer

Mishima is a traditional Korean slip-inlay technique. The Korean pots you see with mishima decoration typically use several colors of slip inlaid into the same piece. I basically use the same black slip recipe for all of my mishima drawing. I always refer to a pattern when I'm drawing on my pots and sometimes use a template to transfer a detail of the pattern (figure 2). In this case, I am using the template to transfer the bird in the pattern onto the cup surface. I make my templates by laminating my own drawing of a found pattern. This is helpful if you are trying to make multiples, but still requires a lot of drawing and interpretation because you're drawing on a three-dimensional surface.

119

9 Use a vitreous engobe mixed with a brushing medium to create color accents.

10 Though it fluxes a bit at higher temperatures, the engobe can be used to fill in color areas on the bottom.

Tumbler, 5¾ inches (15 cm) in height, porcelain, mishima slip inlay, vitreous engobe, fired to cone 6.

Inlaying the Color

All of my mishima is done when the pots are a firm leather hard. Usually they are ready to draw on just after trimming is finished. To follow this technique, start the transfer by gently wrapping the laminated pattern around the cup, taking care to position the image exactly where you would like it to be on the cup. Then, using an African porcupine quill (dull-tipped pencils work well too), transfer the image by tracing over the lines on the template with enough pressure to draw into the surface of the pot underneath (figure 3). Remove the template (figure 4) and use the transferred image as a guide for drawing deeper lines into the surface of the pot (figure 5). You don't need to draw very deeply into the surface for mishima to work. I often feel as though I am just scratching into the surface of the clay. After going over the tracing, finish off the rest of the drawing freehand, using the template pattern as a visual reference (figure 6).

Just before you apply the slip to the surface of the pot, use a soft-

bristled brush, such as a shaving brush, to get rid of as many crumbs as possible. If you don't remove the crumbs, they can often stick to the pot and create problems when removing excess colored slip from the surface later.

Using a wide brush, apply a layer of stained slip to the drawing (figure 7). I tend to use a thinner slip so that it has an easier time getting into the small details of the drawing. Thicker slips tend to only partially fill in the drawn lines in the surface. Once the pot has dried back to the dry leather-hard state and any sheen on the slip has disappeared, begin to wipe away the excess slip from the surface of the pot using a clean sponge (figure 8). You need to clean the sponge often during this process to avoid leaving streaks of color on the surface of the pot. As you work, you'll see your design emerge. The slip remains in the recessed lines of the drawing, creating the inlaid design. Tip: If you are using a clay with a lot of grog, it's a good idea to alternate between using the sponge to remove the slip and smoothing the surface with a rubber or metal rib. At this point let the pot dry completely and then bisque fire it.

Adding Color

On many of my pots, I add color accents to the mishima pattern through painting. I do all of my painting after the pot has been bisque fired and before I do any glazing. For the color, I use a cone 04 vitreous engobe that I mix myself, but commercial underglazes also work well. If you use an engobe, combine it in a 1:1 ratio with brushing medium using a palette knife until it is well mixed (figure 9). The mixing-medium helps make the engobe more brushable and thins it out so that you can build up color in layers, similar to painting on canvas. This layering makes for more solid colors with less visible brush strokes.

The engobe recipe that I use tends to flux a bit at cone six but it can still be used to fill in the line drawings on the bottoms of pots (figure 10). After I finish adding the color, I use a clear glaze over everything except the bottom of the pot, then fire the work in oxidation to a hot cone six.

Drawing Tools

There are many tools you can use to incise the surface of the pot for mishima. I have gone through stages of preferring particular tools—pencil-style X-Acto knives, commercial stylus carving tools (sold in ceramic supply stores), African porcupine quills (available at Santa Fe Clay) among others. My current drawing tool of choice is a calligraphy pen with interchangeable metal tips. It's the same kind of pen that you dip in ink and would use to do traditional calligraphy; I just use it on clay instead.

Molly Hatch working in her studio while she was a resident at the John Michael Kohler Arts Center, Sheboygan, Wisconsin.

Recipes

Andrew Martin's Brushing Slip
(up to cone 10)

Ferro Frit 3110	30 %
Ball Clay	20
Mason Stain 6600 (black)	50
Total	100 %

Add: CMC 2 %

This is the slip I use for the mishima inlay areas on my work. Be sure to mix it thin enough that it fills in all of the fine lines. If using a coloring oxide (like iron oxide, manganese dioxide, chrome oxide, cobalt oxide, cobalt carbonate or copper carbonate, for example) instead of a commercial stain, the amount of colorant needed may be less than in the above recipe.

Vitreous Engobe
(Cone 04–6)

Talc	15.3%
Ferro Frit 3110	18.4
Kentucky OM4 Ball Clay	15.3
EPK Kaolin	5.1
Glomax (Calcined Kaolin)	25.5
Silica	20.4
Total	100.0%

Add: CMC 1.0%
Macaloid 1.0%

Add stains to the above base at a ratio of 1:1. I use this on bisque ware.

Brushing Medium

To make a brushing medium for use with the Vitreous Engobe, slake a 50/50 mix of Macaloid and CMC in hot water and blend together until smooth. To combine the engobe with the brushing medium, start with a small amount of each and use a palette knife to mix them together. Add more medium or engobe until you get the right consistency for brushing.

Val Cushing Clay Body
(Cone 6)

Nepheline Syenite	23 %
EPK Kaolin	35
Tile 6 Kaolin	15
XX Sagger Ball Clay	5
Silica	22
Total	100 %

Add: Bentonite 3 %

I use a commercial cone 6 porcelain from Sheffield Ceramic Supply, however, this Val Cushing cone 6 body is great.

Posey Bacopoulos
Majolica Technique

by Clay Cunningham

Studio Ceramics

Majolica glazing techniques allow Posey Bacopoulos to create both bold lines and areas of bright color, as in the oil and vinegar ewer set above, without the fear of having them run or blur during the firing.

In her numerous workshops, Posey Bacopoulos shares with her students the historically rich and colorfully beautiful process of majolica glazing, a decorative process where colorful imagery is painted over a white glaze. This wonderful technique allows her to create vibrant imagery on pottery without fear of the colors running or blending together as many glazes do when they accidentally overlap. Posey creates and fires her work in her small New York City studio. Majolica is the perfect technique for her as it requires only one glaze, a few overglazes, and an electric kiln. Here's how she does it.

Applying the Base Glaze

The process begins with any leather-hard or bone dry pot made from earthenware clay; Posey uses Stan's Red from Highwater Clay. Before bisque firing, a thin layer of red terra sigillata is painted onto the foot of the pot, as well as any places that are to remain unglazed (figure 1). This creates a nice, rich shine to the exposed clay, and also helps to create a water-tight surface on the pot. When the pot is bone dry fire it to cone 05½ on a slow cycle.

Ceramic Arts Handbook

1 Apply terra sigillata to the lid of the bone dry piece.

2 Dip the exterior. Smooth out any overlaps with a finger.

3 Clean the lip, lid, and foot with a sponge.

4 Draw on the design over the glaze with a pencil first.

5 Outline the floral foreground with black stain.

6 Use a stylus for creating sgraffito decoration.

7 Coat the foreground with wax resist.

8 Designing a 'blossom' with a finger.

Glaze the bisqued pot with the PB Matte Majolica Glaze. Mix the glaze to a consistency slightly thicker than 'normal' glaze thickness. Smaller forms can be dipped using glazing tongs while for larger forms such as the one in this demonstration, the glaze needs to be poured and dipped. Pour the glaze into the pot's interior and dip it onto the exterior (figure 2). Take care to keep the glaze from overlapping too excessively. Heavily overlapped majolica glaze shows the discrepancies of thickness after firing and could crawl or pinhole if too thick.

With a sponge, wipe the foot of the pot thoroughly clean. If making a lidded vessel, remove the glaze on the rim of the pot and the underside of the lid with a sponge to avoid the lid sticking to the pot in the kiln (figure 3). After the glaze dries, smooth out any air bubbles, drips, or pinholes by gently rubbing the surface and dusting off the loosened material. Use a mask or respirator when rubbing or blowing the glaze dust.

Studio Ceramics

9 Add a middle ground around the waxed foreground.

10 Wax over the decoration and brush on the background.

11 Spray the lid using an atomizer for additional texture.

12 Add pattern and line work with black stain or paste.

13 Add sgraffito work on the lid to match the jar.

14 Drawings included on the bottom of the pot.

Inglaze Decoration

Once the piece has 'cured' for a day, it is time to decorate! Begin by using a soft #2 pencil to lightly draw out the decoration (figure 4). Using the pencil first allows you to run through ideas before committing fully with the brush and stains. Decoration can be as minimal as a few dots of color or as elaborate as an overall pattern covering the piece. The choice is up to you. If you make a mistake, it can be gently 'erased' with a finger.

Unlike painting, where the background is usually painted on first, the majolica technique begins with painting the foreground using a stain paste and working backward toward the background so that colors are always painted onto a white ground. For her decoration, Posey often chooses floral motifs. However, the motifs that adorn her work are patterns, rather than actual representations of nature, that she uses to divide and define the space of the pottery in interesting ways.

Mix the stain paste to a thinned

Tall oval box, 8 inches (20 cm) in height, earthenware, with majolica base glaze and overglaze stains.

glaze consistency. If it's too watery, it may drip or run down the side of your pot. Too thick, and the brush will not glide easily across the raw glaze surface. (To learn how to create your own stain pastes, see page 6). Starting with the foreground, apply the stain pastes with a brush. Posey uses a Marx 5 Long Dagger brush which is perfect for long, flowing lines with varied thickness. To create an added layer of interest to your decoration, load your brush by first dipping it into one color and then dabbing a second color onto the tip. When the brush moves across the surface of the pot, the colors gracefully blend together. Loading the brush can add an element of depth and interest to your brushwork.

To boldly outline your shapes, apply a smooth coat of black stain or paste with a Marx Dagger 636 brush (figure 5). Deemed by Posey as the "Magic Brush," this brush is angled at the tip which allows for great line variance as you move it. With practice, beautiful flowing lines are possible. The black lining around the shapes helps to define it from the rest of the pot, as well as creating a dark color on which to carve back through. Known as sgraffito, the process of scratching through the black outline to the white glaze underneath is a great technique to help define a shape or to add a little extra decoration (figure 6). Though any semi-sharp object can be used for sgraffito, avoid using objects that are very sharp or thin, such as a needle tool, as they make lines that are too skinny and offer very little line variance. Posey recommends and uses a Kemper Wire Stylus WS.

After finishing all the foreground decoration, it's time to start working toward the background. Instead of painting the middle ground and background color around the shapes painted on the pot, which can hinder the fluidity and evenness of your background, Posey prefers to wax resist her foreground decoration. Apply a thin coat of wax resist directly over the decoration (figure 7). Once dry, the middle ground and then the background color can be applied directly onto the entire pot and voila, the wax prevents the new stain from absorbing into the glazed pot. If the

Large oval box, 11 inches (28 cm) in length, earthenware with majolica base glaze and overglaze stains.

wax goes outside of the decoration's border, don't worry. A thin white line surrounding the decoration can add a loose, gestural quality to the piece.

Since the foremost decoration is already painted and now waxed, any new overglaze colors brushed over will appear to be directly behind the initial drawings, thus creating a middle ground. Posey uses her finger to dab additional color, for example, creating the center of a 'blossom' (figure 8). The blossoms are then elaborated upon with brushwork (figure 9). Once this decoration has been applied, coat it with wax resist. Depending on the number of layers desired in the drawing, this could be done in one or two steps, or may require multiple sessions of applying decorative elements and waxing.

Once all individual objects of decoration are painted on and protected with wax resist, it's time to give the rest of the piece an overall hue. Though it can be left white, Posey prefers to liven up the surface with a uniting color. To apply the background color, Posey uses a Loew-Cornell 275 brush as it can hold a large amount of stain paste and creates a nice, wide swath of color (figure 10). Here she brushes vanadium stain

> **NOTE**
>
> Even though the wax is dry, allow it to cure for twenty-four hours before touching it with your hands. If it is still damp, it may stick to your fingers and thus pull the stain decoration off. However, the sponge is safe to use on the waxed areas.

paste onto the piece directly over her previous decoration. The entire surface can be colored or the decoration can be painted in any manner or pattern to design the background. To add variety to the surface, a small atomizer filled with rutile stain paste can be sprayed onto the surface (figure 11). This allows for a varied and mildly textured surface similar to pottery fired in atmospheric kilns. After applying the background, use a small damp sponge and carefully wipe over the waxed decoration to remove any beads of residual glaze.

Finishing and Firing

With the entire piece colored, any additional decoration can be added on top of the background color using the black stain or paste (figure 12). Here Posey paints on a grid design which adds additional patterning as well as helping to compose the space within the form of the pot. As before, sgraffito can be used to add variety to lines or for further decoration (figure 13). Don't forget the foot and the inside of the pot. Adding small, yet similar, decoration to the inside of your pottery helps relate all the parts of the work to one another, and gives the viewer an additional 'surprise' to find later (figure 14).

Load the glazed piece into the electric kiln and fire to cone 05. Fire the kiln slowly, particularly in the latter stage of the firing, for a total time of no less than twelve hours. This allows the glaze to even out and allows any additional gasses in the clay to burn off slowly, ensuring that your colors are even and free from pinholes. The good news is that majolica glazes are typically very stable, meaning they won't run. Not only does that mean that you won't have any glaze to grind off the bottom of your pot, your decoration won't run either.

Glaze Materials

Though most surface treatments can be adapted to work in more than one firing range, terra sigillata and majolica techniques are primarily intended only for low-fire. The article on Posey Bacopoulos' work (see page 35) discusses using terra sigillata to create a satiny smooth and more water tight surface and the majolica decorating technique.

Terra Sigillata

Terra sigillata is an ultra-refined slip that can be applied to bone dry (or bisque fired) clay. When brushed onto bone-dry wares, the extreme fineness of the platelets in the terra sig causes them to naturally lay flat on the surface, resulting in a smooth, satiny coating, even with just a very thin translucent layer. If the terra sig is polished when still slightly damp with a soft cloth, the pad of your finger, or a thin piece plastic, it will give a high gloss without heavy burnishing. Terra sig will not run or stick to other pieces in the kiln or to a kiln shelf. It works best at low temperatures including pit and barrel firing, but can be fired higher with adjustments to the mix.

Studio Ceramics

Making Terra Sigillata

Terra sig can be made from any clay, though some have a smaller particle size and will have a greater yield. No matter what clay you use, in order for terra sig to settle properly, it must be deflocculated, which makes the particles repel one another and keeps the finest particles in suspension. To achieve the best results, use a combination of 1 part sodium silicate and 1part soda ash, based on the dry weight of clay. Weigh out the deflocculant and dissolve thoroughly in hot water (already measured into a larger container). Slowly add the desired clay and blend thoroughly with a mixer or a large wire whisk. (Red or white earthenware can be used and colorants can be added to both after the middle layer is extracted). Allow the terra sig to sit undisturbed for several days or until three distinct layers become visible. Delicately remove the middle layer using a ball syringe or similar device, being careful not to overly disturb the mixture as a whole. This middle layer is the terra sig. Put it in a separate container for use. The top layer will be mostly water and the bottom layer will essentially be sludge, both can be discarded. The sig layer is now ready for use or can be colored if desired, generally 1 cup of sig to 1 tbsp. of stain.

Majolica Stain Pastes

Majolica stains are made with frits and/or Gerstley borate, which are fluxes and glass formers. They allow the stain pastes to melt into the white base majolica glaze they are layered on top of and add to an overall and consistent glossy finish. Majolica is a low-fire technique, you can use any commercial stain or coloring oxide to achieve the color you want.

Always test your recipes first before using them on finished work. And always wear a respirator or similar safety equipment when handling dry materials.

Applying terra sigillata to foot of the bone dry pot.

Add stain paste base to the colorant, 3½ parts paste to 1 part colorant by volume.

Mix the stain paste to the consistency of peanut butter.

Prepared stain pastes. Consistency remains the same with each batch.

Recipes

Toasty Red Brown Terra Sigillata
Cone 05

Water	14 cups
Red Art Clay	1,500 grams
Sodium Silicate	1 tsp.

Mix thoroughly and allow to settle into three distinct parts. Pour off the top, thinnest layer. Pour the remaining liquid (middle layer) into a lidded container to use as your terra sigillata. Discard the bottom sludge. Use on leather-hard or bone dry ware.

PB Matte Majolica
Cone 05

Ferro Frit 3124	65%
EPK Kaolin	20
Dolomite	10
Silica	5
Total	100 %
Add: Zircopax	10%
Epsom salts solution	

Put water into a mixing container and add dry ingredients. Once settled, stir vigorously while adding a saturated Epsom salt solution (approximately 1 tsp. per 1000 gram batch). Add water to achieve a thick, creamy consistency slightly thicker than a typical glaze. To make a saturated Epsom salt solution, mix Epsom salts into a cup of water until no more will dissolve.

Stain Paste Base
Cone 05

Ferro Frit 3124	50%
Gerstley Borate	50
Total	100 %

Mix by volume. This is the base recipe for making colors to paint on over the base glaze.

Stain and Oxide Colorants

For commercial stains, the ratio should be 3½ parts Stain Paste Base to 1 part colorant by volume. (Most commercial stains will work, but test first.)

Green: Mason Florentine Green 6202
Mason Bermuda Green 6242
Blue: Mason Navy Blue 6386
Yellow: Mason Vanadium Yellow 6404
Purple: Mason Pansy Purple 6385
Chartreuse: Mason Chartreuse 6236
Brown: Mason Chocolate Brown 6124
Gray: Mason Charcoal Grey 6528
Black: Duncan EZ Stroke Black EZ012

For oxides, mix 1 part Stain Paste Base to 1 part oxide by volume.

Brown: Red Iron Oxide
Turquoise: Copper Carbonate

For all Stain Pastes, mix to the consistency of creamy peanut butter and thin as needed for brushing.

Amaco Majolica Decorating Colors (GDC series)

GDC Red #54
GDC Purple #55
GDC Royal Blue #21
GDC Avocado #47
GDC Real Orange #65
GDC Rose #38

These work great right out of the jar to be brushed onto the Majolica Glaze. For other colors, see the Amaco catalog.

Test tiles of stain pastes painted over majolica and glaze fired to cone 05.

Hang It Up

by Annie Chrietzberg

Christine Boyd's "Crow Platter" performs double duty as a wall hanging artwork and a functional serving dish.

I first came across Christine Boyd at an art fair. Her booth was irresistible—the work drew me in with its high-contrast, dynamic surfaces, which read well from a distance. Upon approach and engagement, my interest continued to grow, to the point where I had to own a piece. Christine's work has a rough-hewn aesthetic that carries through form, decoration, and also, I discovered as I used it, function. Her plates are burly enough for everyday use, but not at all cumbersome and stack well.

The wonderful thing about Christine is that she naturally dwells on more than form and function and doesn't attempt to rein it in. In addition to surrounding herself with decoration and pattern, she has a mind that travels beyond the usual boundaries and an innate sense of engineering. These interests are clearly evident in the efficient system she's designed for hanging everyday plates that's easy to use and remove (figure 1).

Christine's system uses common sewing snaps and picture-hanging wire (figure 2) to create removable hanging devices for serving pieces and everyday plates. She carves keyhole-shaped grooves into the backs

1 The back of one of Boyd's plates, with the wire in place.

2 The wire is held in place by a sewing snap fastened to it.

3 The hanging wire in the slot on a finished, fired plate.

4 Tool #1, used to create the circle at the bottom of the slot.

of her plate rims when they are in the leather-hard stage. The grooves have a bevel or undercut below the surface to hold the snap on the hanging device in place (figure 3).

Christine made three special tools for creating the slots that correspond to the shrinkage of her clay body and the size of the snaps. She makes these tools out of long straight pins (the kind used for quilting), dowels and lots of hot glue. "I don't make tools for reasons of economy, but rather because the things I need don't readily exist," she explained. "I'll come up with an idea that needs a specific shape, and rather than spend weeks looking for something, I'll just get out some metal and pliers and make what I need."

Tool #1 is used to start the slot and it looks like a square trimming tool with a wire extension on one side (figure 4). This longer wire acts as a pivot point to facilitate the cutting and removing of a disk of clay (figures 5 and 6). The other end of the tool is used to smooth out and compress the cut surface.

Once the disk of clay is removed, she uses tool #2 to cut the slot (figure 7). She makes three cuts with this tool. For the first cut, she holds the handle horizontally, level with the surface of the plate (figure 8). Starting at the circle, she cuts a groove

Studio Ceramics

5 Insert the tool into the clay until the pivot point hits the works surface, then twirl it to make a circle.

6 Lift the tool after completing the circle to remove the disk of clay.

7 Tool #2, a rectangular loop of wire on a stem, creates the slot and channel for the wire and snap.

8 Holding tool #2 horizontally, place it at the top of the circle, level with the surface.

that's about an inch long towards the top edge of the plate. She finishes the cut with a quick upward flick, and carefully removes the trimmed clay (figure 9). This cut goes through the surface of the clay and exactly matches the depth of the circle, but doesn't cut through to the front side of the plate rim.

The second and third cuts are made by holding tool #2 vertically to create cuts that run beneath the surface on either side of that first slot, to create a channel beneath the surface of the clay that will allow the snap to travel up to the top of the slot and hold the wire securely in place (figure 10). Cuts two and three are started at the top of the channel and cut back towards the circle, by inserting the cutting edge of the tool through the channel and rotating it clockwise for the right side, and counterclockwise for the left side (figure 11). This is the only way to cut these, as the bit of clay cut away with each stroke needs to be removed through the circle. It's very important to note that all these cuts are meant to create a smooth and level gallery or channel for the snap below the surface of the back of the plate.

Christine then uses tool #3 to tamp down, gently widen and smooth this internal space so that the snap may travel freely in and out (figure 12).

133

9 Drag the tool up towards the top of the plate so that it cuts a channel or slot in the surface.

10 Insert tool #2 vertically into the slot to create undercuts on both the right and the left of the channel.

11 Starting at the top of the channel, move towards the circular opening so you can easily lift out the clay.

12 Use tool #3 to compress, smooth and widen the surface of the inside the channel.

TIP

Bits of grog can obstruct or hinder the smooth operation of a sliding snap so be sure to press bits of grog left behind into the surface.

To get the correct amount of wire, Christine stretches the wire across the back of a finished plate, measuring roughly 2½ inches past each slot (figure 13). She uses 15-pound weight, plastic-coated picture-hanging wire rather than the uncoated type because it's kinder to her hands as well as the user's hands. She recommends you also buy one of the special picture wire winder tools available at frame shops and hardware stores that make tidy, secure coils. The last thing you want is for that wire to unravel and have a plate come crashing down!

Christine first feeds the wire through the front side, then through the back of the snap, so that the loop of wire is at the back of the snap (figure 14). Then she takes a pair of snub-nosed pliers and gives the wire and the snap a good crunch to compress both the wire and the snap itself (figure 15). She uses both the male and female sides of snaps, they both work fine. Next, she feeds the wire into the coil-winding tool, which secures the snap in place (figure 16). After one side of the wire is complete and put in place, Boyd presses the middle of the wire up to the point she wants it to be when the plate is hanging on the wall (figure 17). She

Studio
Ceramics

13 To find the length of wire, pull it across the back of the plate and add 2½ inches beyond the slots.

14 Thread the picture-hanging wire through the snap from the front side so the loop is on the back side.

15 Use snub-nosed pliers to compress both the wire and the snap, to avoid having the mechanism snag in the channel.

16 Using a wire winder, secure the snap onto one end of the picture hanging wire.

17 Insert the completed end, press the middle of the wire up to the appropriate amount, then bend the other side of the wire where the snap should seat.

then bends the other side of the wire where the snap should seat, and repeats the process of threading a snap, crunching it and creating the wire spiral.

When Boyd sells a piece with one a hanging mechanisms, she demonstrates how to install and remove it. She also includes a card that says, "This hanging device is designed to be removed easily, to allow the plate to be used for serving food."

It's the little extra things like Boyd's hanging devices that go a long way toward opening up dialog with a stranger who approaches you and your work!

135

Your Source for Inspired Techniques
THE CERAMIC ARTS HANDBOOK SERIES

- Raku, Pit & Barrel — Firing Techniques
- Throwing & Handbuilding — Forming Techniques
- Surface Decoration — Finishing Techniques
- Extruder, Mold & Tile — Forming Techniques
- Glazes & Glazing — Finishing Techniques
- Electric Firing — Creative Techniques
- Raku Firing — Advanced Techniques
- Ceramic Art — Innovative Techniques
- Ceramic Sculpture — Inspiring Techniques
- Ceramic Projects — Forming Techniques
- Studio Ceramics — Advanced Techniques

ceramicartsdaily.org/bookstore
866-672-6993